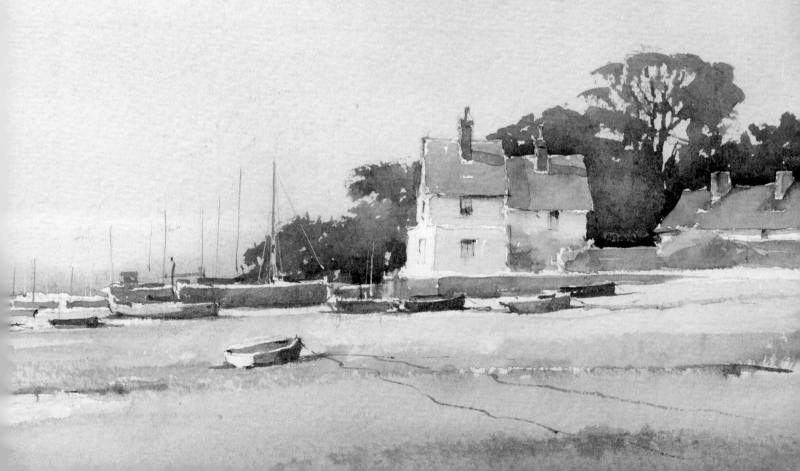

William Newton's
Complete Guide to Watercolour Painting

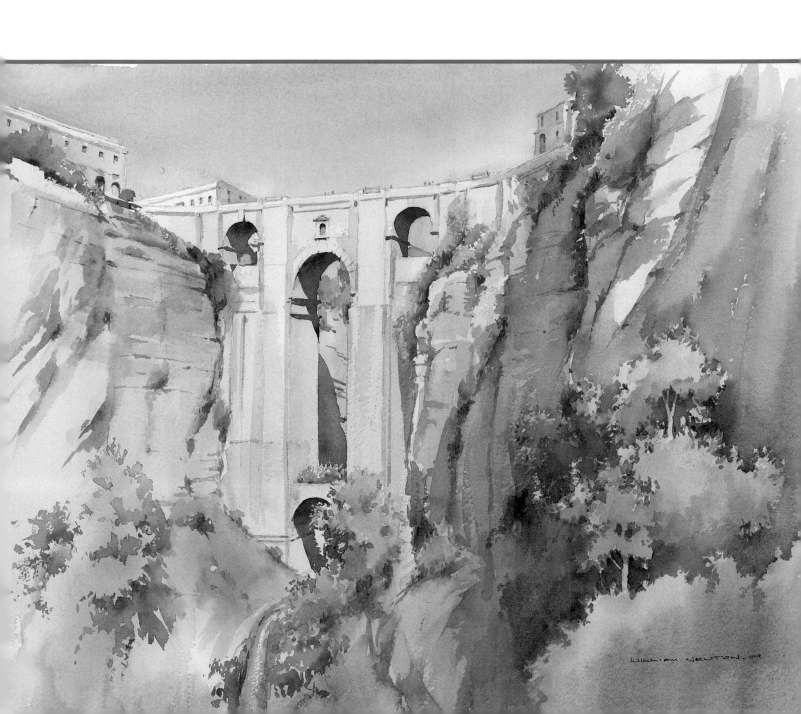

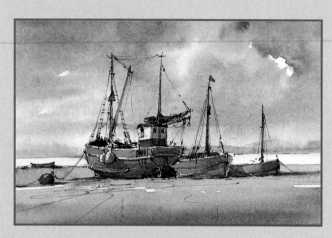

Dedication

For my wife, Susan, for all her help and support;
and for my now extended family, Emily, Russell,
Aimee and Barnaby, Daisy and Tabitha.

Also in memory of my brother David.

William Newton's
Complete Guide to Watercolour Painting

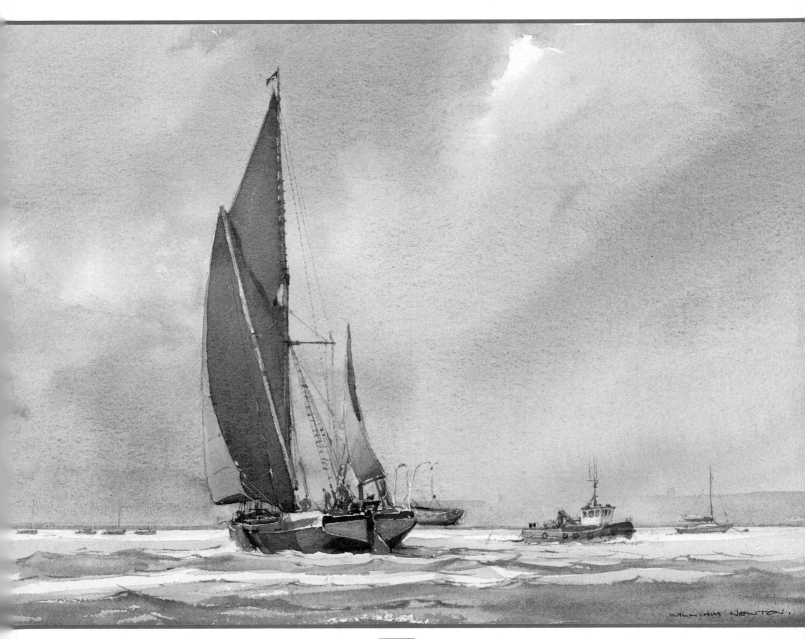

Search Press

First published in Great Britain 2013

Search Press Limited
Wellwood, North Farm Road,
Tunbridge Wells, Kent TN2 3DR

ISBN: 978-1-84448-830-8

Suppliers

For details of suppliers, please visit the Search Press website: www.searchpress.com.

You are invited to the author's website:

www.williamnewton.com

Printed in Malaysia

Acknowledgements

My thanks to Hugh Gilbert for allowing me to use his splendid photograph of my friend, the late John Seabrook. Also to Mr and Mrs Roe for allowing me to use the watercolour of Angles, France on pages 6 and 7.

Cover
Detail of *Breezing Along on a Starboard Tack*

A detail of the feature sailing barge from this painting, shown in full on page 3.

Page 1
The New Bridge, Ronda, Andalucia

A studio painting from a smaller location work. This is a spectacular and beautiful structure with a somewhat grisly history.

Page 3
Breezing Along on a Starboard Tack

This painting was produced from a drawing made during a painting holiday while on board another boat.

Opposite
Vinci, Tuscany

Produced on a painting holiday in Italy at the home town of Leonardo da Vinci, this small piece of work was painted quite quickly.

Contents

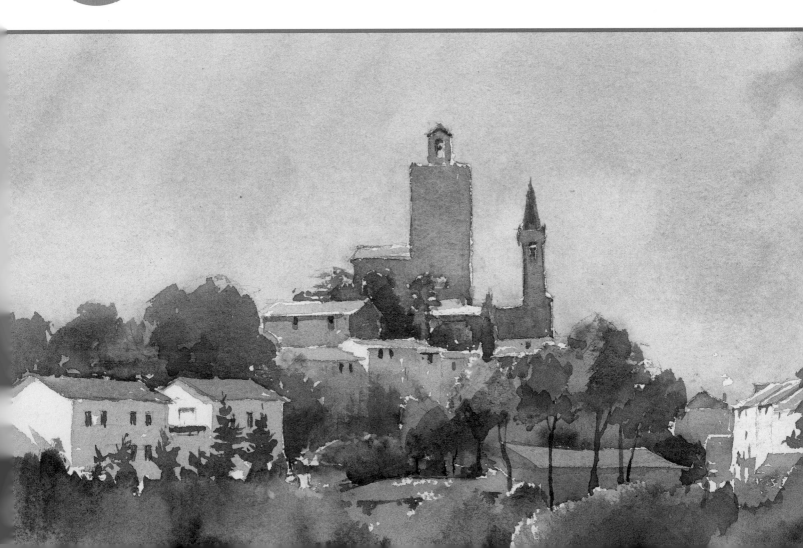

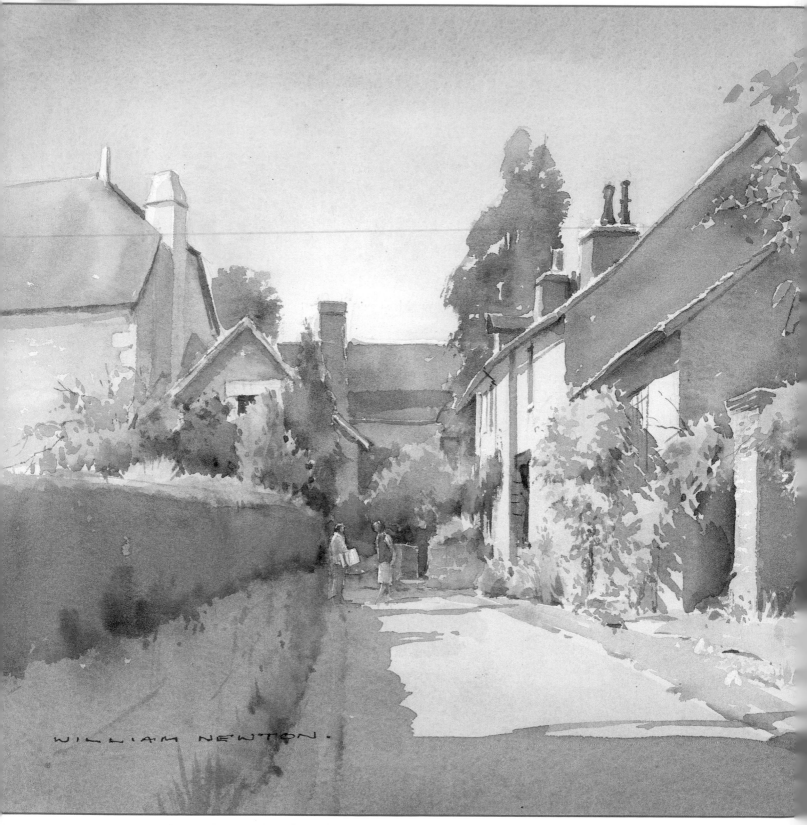

Angles sur l'Anglin, Vendée

This villagescape was painted en plein air *on my day off from tutoring a painting holiday in this lovely village. From the collection of Mr and Mrs Warren Roe.*

Introduction

Painters like myself, without formal art training, are said to be self-taught. That rather belies the truth; as I have learnt much from many artists – both my contemporaries and those great painters who have gone before, whose wonderful work I have studied along the way.

As your interest develops you may find that your taste in paintings in general – and watercolours in particular – may change. The paintings that you admired when you started may not be the ones that you like now. Most people start off by trying to paint absolute reality, every last detail, almost to a photographic degree. In short, attempting to be a camera with a paintbrush. Of course, you may strive for perfection and fall short, but be patient; improvements will be made and great pleasure will be derived from the pursuit.

Alternatively, rather than attempt to beat the camera at its own game, you might aim to produce something which is rather nicer, a watercolour which fully exploits the wonderful properties of pure, transparent watercolour pigment on lovely, inviting watercolour paper – perhaps something impressionistic and evocative where detail is only suggested. Parts of the work can be exaggerated where required. Emphasis, light, colour and tone can all be adjusted, modified or changed to suit compositional considerations.

I have never seen painting as a competition, nor painters as rivals but more as people whose work I can enjoy and learn from in the lifelong quest for self-improvement. You only need to compete with yourself, with your last effort.

Furthermore, painting need not necessarily be affected by age. One can start at any age and still reach a high level. I have known artists to still be painting at the age of one hundred. It may be that maturity helps in influencing one's approach to a given subject.

Whatever your aim, this book will provide guidance and specific suggestions on what to use for the best results. I hope that you find it useful.

Painting basics

I have come to the conclusion, after many years, that there are three basic areas of learning that you ought to consider in being a painter. These are listed below, and should be borne in mind throughout the book, and into your day-to-day painting.

Learning to see

You have to relearn to see, to retrain your eyes to see the world in the way of the artist, to fine tune and improve your powers of observation so that the most minute subtleties get noticed. You have to learn to select that which is important from that which is not. The paradox is, if you half close your eyes you will see less detail but more of what matters.

Mechanics

To put down your good ideas you need to develop skills and techniques, to improve your drawing and painting methods, to learn how to use colour, mixes, equipment and how to choose your equipment. Most teaching and tuition seems to concentrate on this area.

Technique alone, however fluent, is not enough, but it will teach you how to put down your inspiration on paper.

Flair

Developing a sense of flair within your work – to improve compositional skills, to establish and exploit a sense of style, to make your pictures work visually – is a more elusive part of painting. You need to produce images that use interpretation and maybe simplification to become interesting and effective.

We should never stop learning or seeking to improve – although it is neither an onerous task nor a chore, but a pleasurable pursuit!

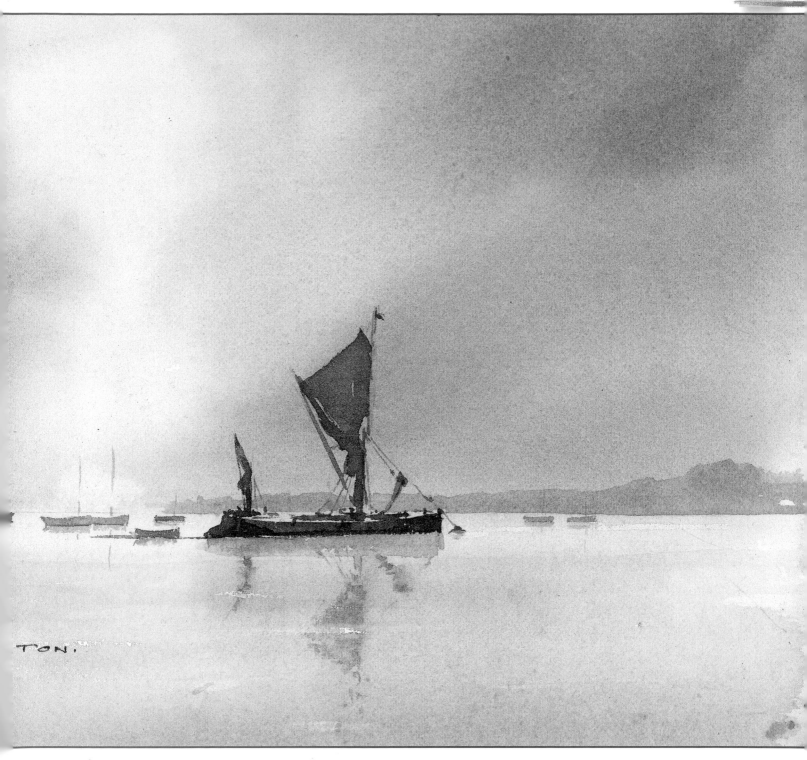

Thames Barge, Morning

On a calm day, while at anchor or at a harbour mooring, you will often see one or more of the sails of such barges hoisted so that they can be dried before being reefed. This is a very small painting depicted larger than its actual size.

Materials

Regarding advice on which materials to use, I often see the advice, 'Try this and try that and see what works for you'. To a beginner and even a more advanced painter, I feel that being specific is more useful and helpful.

In this section, I recommend the particular materials I use, and suggest what you should buy as a starting point. You may then develop your own individual preferences as you gain experience.

Watercolour paper

There are many types of watercolour paper available on the market with three basic surfaces: hot pressed, cold pressed and rough. Most practising watercolour artists use either cold pressed or rough surface papers. Watercolour paper can be bought in imperial sheets of 760 x 560mm (30 x 22in), in various size pads, and also in blocks which have gummed edges that are intended to keep the paper flat during painting.

I favour Saunders Waterford Rough for most of my work, using 300gsm (140lb) weight for quarter sheet pictures of 380 x 280mm (15 x 11in) and 425–638gsm (200–300lb) for larger work. It is a superb paper of remarkably consistent quality, made of one hundred per cent cotton. This paper is available in both a creamy white and a bright 'high white'. I use both as there are subjects that work well with the warmer base colour for a harmonic effect, while at other times the pure white will pay dividends – especially when little bits of paper are left unpainted.

Another paper popular with professionals and amateurs is Bockingford. It is a hardy paper and available in all the usual thicknesses. I find it useful when painting subjects such as portraits or animals which might call for lifting and generally pushing the pigment around. I especially like Bockingford's tinted papers as they come in interesting colours.

If you choose not to use either of these types of paper, try to find a paper with similar characteristics and qualities. I cannot stress enough the importance of good paper for watercolour painting. Quite simply, you will get better results with a good paper and it is worth every extra penny.

I do not stretch paper. This is the age-old practice of soaking a sheet of paper in water for a while, then taping it down on to a board. As the paper dries it contracts to a drum tightness, which is intended to stop the paper buckling or 'cockling'. I find that at the stated sizes/weights there is no real problem using dry paper.

A variety of different watercolour paper surfaces.

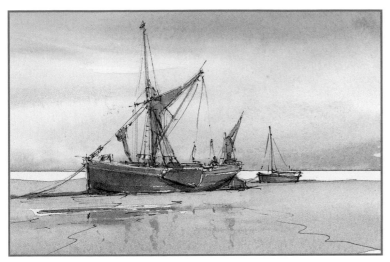

Hot pressed paper

Known simply as HP paper, this has a smooth surface and consequently a slightly faster drying time. These qualities make it ideal for pen and wash pictures, as shown to the left.

While any of the surface types can be used for pen and wash – each allowing for different styles and effects – the smooth surface of the paper lends itself to the pen and fine detailed work. It is also suitable for smaller paintings and sketches where texture might be intrusive or inappropriate.

Cold pressed paper

This is also known as Not paper, which is shorthand for 'not hot pressed'. It has a moderate texture and is a nice all round paper preferred by many artists. The sketch to the right is painted on cold pressed paper.

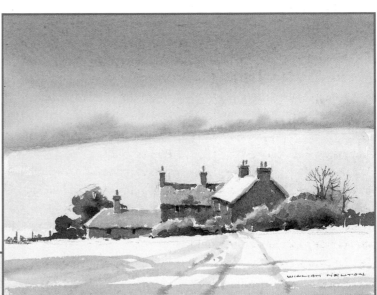

Rough paper

Rough paper is wonderful for dry brush work, as in the tree to the left, and for creating surface textures and granulation. Pigment settles wonderfully into the rougher surface of this paper.

Brushes

As with all art materials, there is a baffling variety of paintbrushes available. One can pay enormous sums of money for watercolour brushes. I tend to eschew gimmicky brushes, and prefer the reliable qualities of round kolinsky sable brushes and synthetic flat brushes.

When choosing which brushes to use, I suggest the following as an excellent basic set, suitable for most watercolour subjects: sizes 10, 6 and 4 sable rounds; a size 2 sable rigger; and 37mm (1½in), 25mm (1in) and 12mm (½in) synthetic flats. All of my brushes come from Rosemary and Co, as I find them of superb quality and value. If you choose not to use these, then try to find brushes with similar qualities, as described below.

The largest synthetic brush I use, the 37mm (1½in), is a series 303 flat. This has relatively longer bristles to hold more water, which makes laying in large washes easy. The smaller synthetic brushes are series 302 brights, which means the bristle length is relatively short, and the head looks square. This gives you a lot of control, particularly at the edges of the brush, which is excellent when trying to work around architectural details and smaller or tighter areas. I use synthetic brushes for larger areas of the work as they are more resilient and cheaper than sable. In my experience, the series 302 and 303 synthetics are so tough that they never wear out!

My round brushes are drawn from the series 33 and series 44 sables. Both are formed to taper to a fine point from a full body. Sable is particularly good at holding water, which allows the brush to hold a reservoir of wet paint. In turn this means you have plenty of paint to work with, reducing the need to reload your brush midway through a stroke or wash. The series 44 brushes are riggers, which means they have very long bristles that allow you to paint long lines without reloading too often.

All round-pointed brushes will gradually lose their pointed tip, especially when used on rough papers, so I regularly replace mine every few months. Old brushes are useful, however, so do not throw them out. You can use them to apply drawing gum or masking fluid, for example. If you would prefer a dedicated brush for applying drawing gum, a couple of small – size 2 or 3 – cheap synthetic rounds are perfectly fine. Old brushes are also good for dry brush work.

Round sable brushes

The pictures below show details from other paintings in this book; and help to illustrate when you might use a certain brush. Of course, do not feel constrained by this – a size 12 round with a good point can be used for the whole picture (depending on the style you want), including the detail!

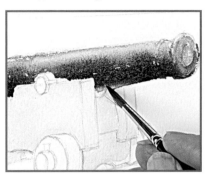

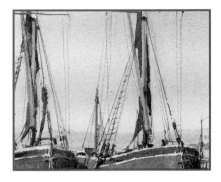

Size 12 round – general massed-in areas where a point is required

The jacket is a pale yellow colour – the exact hue of which changes with the effect of light and shadow – added wet into wet using the size 12 round brush. The point allows you to produce a mixture of hard and soft edges, such as under his elbow and forearm. This detail is taken from Barge Skipper *on page 29.*

Size 6 round – smaller areas that require more control

For this in-progress cannon picture (taken from the project on pages 108–113), a size 6 round brush was used because it is a smaller area than the Skipper's jacket shown to the left, and so required slightly more control.

Size 2 rigger – very fine details

This detail, taken from Tide Out at Pin Mill *on page 51, shows the result of using a rigger. Fine lines – some made with the help of a ruler and some not – are kept simple.*

Flat brushes

Rather than the finer detail you can produce with round brushes, flat brushes are fantastic for laying in large amounts of colour, but used well, they also allow a surprising degree of control.

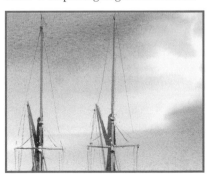

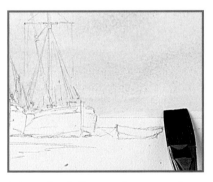

37mm (1½in) flat – laying in larger areas, such as sky washes

Another detail taken from Tide Out at Pin Mill *on page 51. The soft edges of the blue and purple areas of colour show the effect of using the 37mm (1½in) flat brush to wet the paper prior to laying in the bigger washes.*

25mm (1in) flat – tighter control of washes

This brush is often used in concert with the 37mm (1½in) brush for smaller massed-in but shaped areas. In this detail, taken from the Barges on the Mud *project on pages 78–85, the sky is still wet from the larger brush. Using the 25mm (1in) brush, we can add a sharper line to indicate the horizon.*

12mm (½in) flat – distant details

This detail is taken from the background of Tugboat on the Thames, *on pages 30–31. It shows how the subtle background architecture has been painted in using a 12mm (½in) brush for more control. It allows quick execution of complicated areas such as distant chimney stacks and pots.*

Paints

Watercolour paints are made up of pigments bound with a watersoluble binder. Some of the pigments used in watercolour paints, like yellow ochre and its derivatives, have ancient origins going back to Stone Age man's cave paintings, while others use very moden synthetic ingredients. Some ingredients with which these paints are made have changed from their traditional source: French ultramarine is no longer made with semi-precious lapis lazuli, and sepia no longer gets its colour from the ink sac of the cuttlefish. Both, and no doubt many others, are now made synthetically.

I use very few colours on any given picture because I believe I am more likely to achieve a harmonic result by doing so. I do, however, constantly review my palette of colours and experiment with different mixes endlessly (see pages 18–23). I might also use a variation in my palette of colours from one painting to the next.

While I fall back regularly on favourites such as French ultramarine, burnt sienna, raw sienna and lemon yellow, I like to have a sense of adventure by experimenting with other mixes and other colours. By doing so I hope to keep my work fresh. I keep about twelve or so paints in my palette but rarely use more than six or seven on any given piece of work.

In choosing the colours to buy I look carefully at permanence and light fastness (see opposite), as some pigments are fugitive and fade with time. After all, we would all like to think our work will survive for posterity!

I do not stick to any one manufacturer, preferring to cherry-pick from various different manufacturer's products. For example, Daler Rowney warm orange (633) and their warm sepia (250) are both excellent. I like Schmincke's colours, especially their versions of raw sienna, ultramarine finest and lemon yellow.

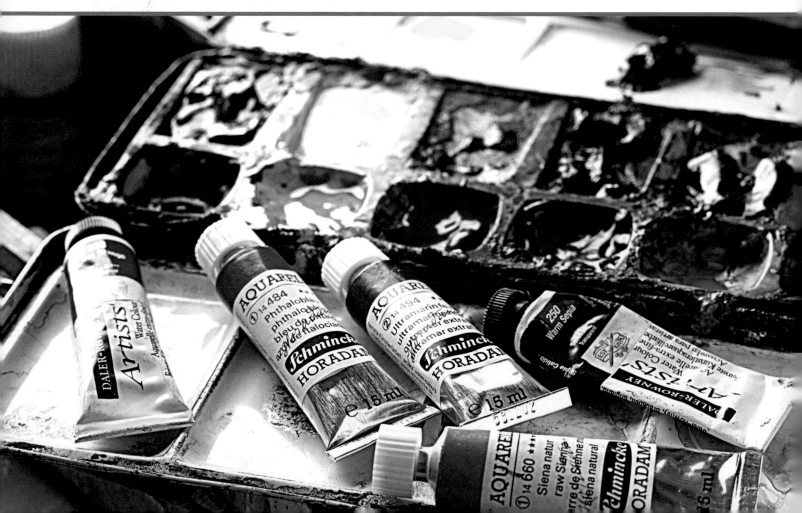

Qualities and characteristics of watercolour paints

I do not consider myself to be an expert on watercolour pigments: I can only pass on experience gathered over more than thirty years as a full-time painter. I believe that art in general is a life-long learning process and one should always be ready to learn. It has been my experience that the various manufacturers have their own different versions of colours that share the same name and that some colours have several different names. For anyone new to watercolour it is best to buy only a few and to fully explore what they will do.

Tubes and pans

Watercolour paints are available in tubes or pans. I prefer tubes because the pigment is already liquid. This means it comes to life more readily than pans and you do not have to wear out your precious brushes trying to activate solid paint. It ought to be noted that some colours set more quickly than others, even when squeezed from tubes. For example, burnt umber will set rock hard in a fairly short time while others will stay moist for days. They will all, of course, still work perfectly well when stroked with a wet brush.

Permanence

When buying any colours I always check their permanence rating as some pigments are inclined to fade quickly.

Working life

Part of the fascination of paint pigments is that they come from different origins and ingredients and, consequently, can behave differently.

Transparency and opacity

Some colours, such as the lemon yellow above on the left, are more transparent than others – meaning they lend themselves particularly well to techniques like layering thin washes (glazing) as the colour beneath can be seen through the colour above – while some are more opaque, like the light red (above right). With enough water they can all be painted with reasonable transparency.

Granulation

French ultramarine has a tendency to granulate (see above), especially when mixed with some other colours. Granulation is the term for the effect caused by relatively coarse pigment settling into the texture of the paper. It is one of those watercolour effects that I love. It is especially good for creating atmospheric impressions and works very well with a little yellow as middle distance foliage.

Colour temperature

Paints have different temperatures – tending towards either being warm, cool or neutral. Cobalt blue (above left), for example, is quite a cool blue and works very well as a background colour to create recession. Cadmium red (above right) is a warm red, and will appear to advance.

Other materials

Some of the other items needed can be improvised inexpensively.

Kitchen paper or any similar absorbent tissue is useful for drying your brushes, and also for lifting out wet paint for certain effects.

A piece of **board** is used to support your work while you paint. A 40 x 30cm (16 x 12in) piece of hardboard or plywood would do, though I use a piece of foam board which is very light. Weight is a consideration when doing outdoor painting.

A **jar** or **plastic carton** makes for a good water pot to rinse your brushes, maybe with a wire loop to hang it from the easel.

For **masking fluid**, I favour Pebeo drawing gum, because it does not deteriorate with age in the bottle, it is very controllable and can be used thinly, and can be washed out of your brush if you are reasonably quick. Above all, it holds to accurate positioning. Look for these qualities in your masking fluid.

Most people have a **camera**, which is useful for gathering reference.

Your **sketchbook** can be any size. I use one that is 21 x 29cm (8¼ x 11¾in) and find it ideal.

For assistance when drawing or painting straight lines, you will need a rigid **ruler** that does not flex too easily.

White acrylic ink is sometimes used to add additional detail over watercolour. I have found Daler Rowney's FW Artists' ink to be excellent because it has good covering power and does not show when dry (as gouache can). I do not know of other inks which have quite the same qualities but one could use white acrylic paint, thinned or otherwise. One could use gouache but – as mentioned above – it is usually very visible and opaque on a painting. Chinese white watercolour paint could also be used as a substitute, but by comparison it is very weak.

A couple of **pencils** are essential: a **2B** for drawing out your watercolour, a **4B** for tonal sketches where shading or hatching may be used. A **pencil sharpener** or a good **pocket knife** will help keep them sharp.

Edding have a nice range of **fineliner pens** perfect for use in the pen and ink technique; 01, 03, 05 and 07 denoting differences in the nibs. There are several other makes producing similar products and, of course, one could use a bottle of Indian ink and a dip pen.

A **brush pen** is like a fountain pen except that it has a brush instead of a nib. The replaceable cartridge holds lightfast waterproof Indian ink. I like to use Pentel brush pens, because the brush nib is more like a traditional paintbrush – some others, like Faber Castell's range, have a harder felt-tip type nib.

To prepare and mix your colours, you will need a **mixing palette**. An inexpensive plastic mixing palette with large mixing areas or a white soup plate is ideal!

When removing pencil lines, use a soft **putty eraser** so as not to damage your delicate watercolour paper.

Finally, you will need some sticky tape: **picture tape** is ideal. It looks like masking tape but is brown in colour and high-tack.

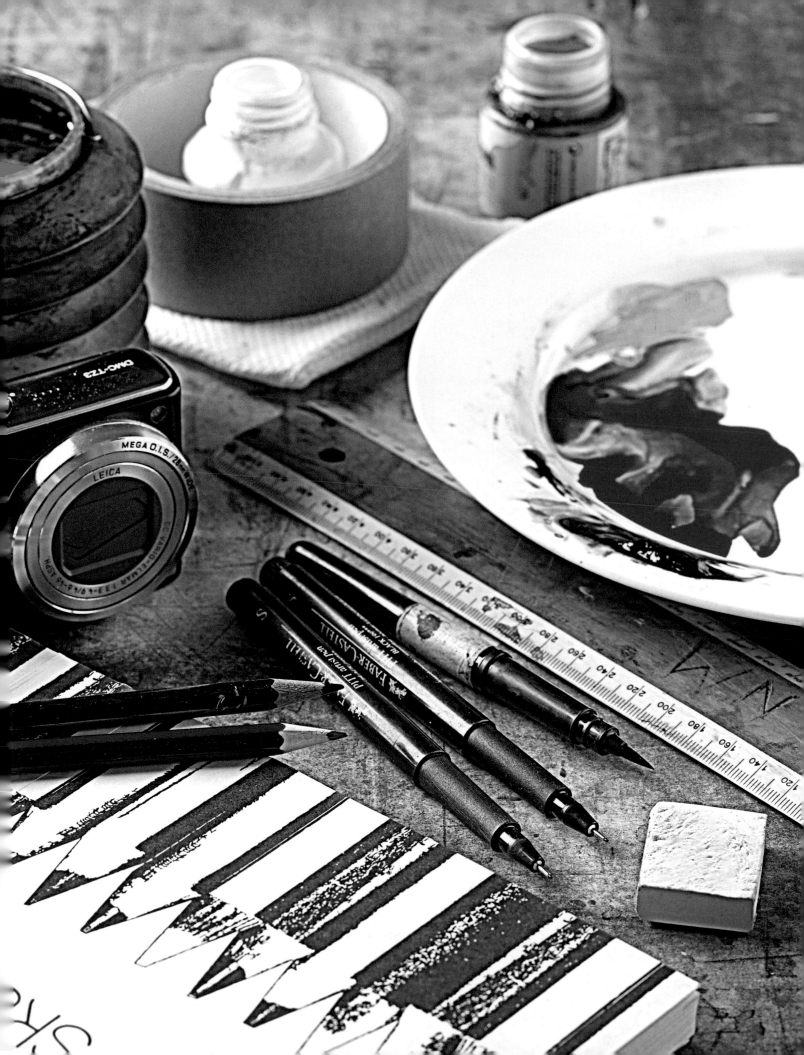

Colour

My paintbox contains twelve colours that I use regularly, the choice of which has been made over years of painting many pictures. I have found by limiting the number of colours used in a composition, I am more likely to achieve a harmonic result, so I rarely use more than six or seven in any given painting. While leaning heavily on French ultramarine and raw sienna, I like to vary the colours used and constantly review the colours in my box, occasionally making a change.

When talking of colour, we must always remember the colour of the paper, usually white. Since watercolour is a transparent medium, the white plays a very important part. It is often said that the best areas of a watercolour are the untouched bits of white paper shining through!

Choosing your palette

I recommend a palette of colours starting with one colour for a monochrome, three or four colours for a limited palette painting (as shown to the right, and on the following pages), to a more expanded set having twelve or fourteen colour from which to choose.

Always remember that using too many colours will often result in a muddy painting. A harmonic, clean, transparent watercolour is far more likely to be achieved by limiting the number of colours to about six or fewer on any given piece of work.

For some specialised subject matter, notably flowers, one may need or prefer some more unusual pigments, such as rose doré, rose madder, permanent magenta and cobalt violet.

My palette

My core palette of colours and their makers are as follows: cobalt blue, lemon yellow, cadmium red and light red from Daler Rowney; and French ultramarine, cadmium yellow and madder brown from Schmincke.

I also use raw sienna and burnt sienna from Schmincke; and warm sepia and warm orange from Daler Rowney. Occasionally, I will use other colours such as raw umber, Naples yellow, burnt umber, permanent magenta and Van Dyke brown.

For any individual painting, I can either draw a select few from this core palette, use the whole core palette, or even add a few select alternatives.

The limited landscape palette used for this exercise

The colours below have been selected as a good palette for a typical landscape.

Lemon yellow

When combined with French ultramarine or raw sienna, this produces useful green mixes.

Light red

This is used for some terracotta colours in landscapes for details like building, roof tiles and so forth. It combines well with raw sienna.

French ultramarine

This is used for skies, and is also perfect for shadow glazes.

Raw sienna

Used for the initial washes, it brings warmth to the palette – and the resultant painting.

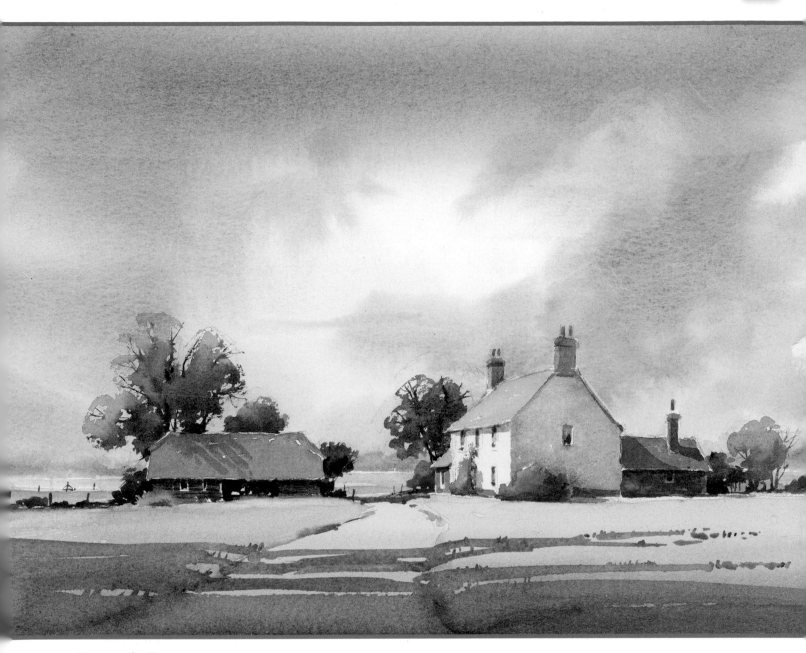

Farm on the Fens

This simple scene was painted using only the four colours of the basic landscape palette (shown opposite) as an exercise. It was painted from light to dark: all the main areas were massed in before washes – mainly French ultramarine – were added to put in shadow areas on the buildings and foreground.

Transparent palette

Winsor yellow

Very transparent, Winsor yellow is a clear, bright, acidic colour.

Winsor red

A staining colour that can be powerful in mixes, this provides our primary red for this palette.

Winsor blue (green shade)

Like Winsor red, this is a powerful colour, and should be used with caution as it can overinfluence your paintings.

Yellow ochre

This earth colour can give an attractive warming effect to your painting, but it is opaque – if mixed with too many other colours, it can go muddy.

Using colour

Having stated my preference for a limited palette, I very much like to experiment with trying new colour mixes and buying the odd new tube. Occasionally, I try a painting with a different set of pigments. The examples on the following pages show different palettes. Note that they retain three primaries and one earth colour in each. This is to allow easy comparison between the three.

Transparent palette

In the painting opposite I have used transparent colours as far as possible with Winsor yellow, Winsor red and Winsor blue (green shade). These are very transparent, and all on the cool side. In addition to these, I chose yellow ochre instead of raw sienna as the earth colour for this palette. Yellow ochre, a semi-opaque paint, was selected to warm the white of the paper. The transparent colours can then be used to glaze over the top, and this will ensure the warmth is retained in the finished painting.

As mentioned on page 18, the colour of the paper may influence your choice of colours. The painting opposite is painted on Bockingford grey tinted paper. Notice how white the untouched paper looks when surrounded with darker washes. The use of transparent colours ensures that the surface colour shows through a little, which helps to bind the overall picture together.

Note

These colours are not part of my usual palette, but have been used in the interests of variation and exploration. Once you are familiar with your palette of colours, I recommend you experiment by sampling other colours. Do not replace the whole palette in one go or make too many radical changes; but I would encourage the spirit of experimentation and adventure in your choice of colour.

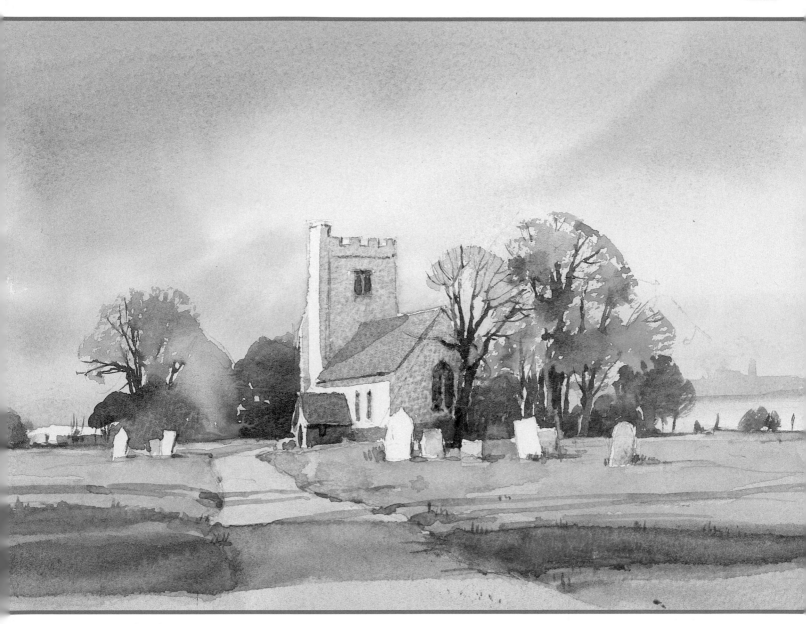

Country Church

A free, wet wash of yellow ochre warmed the foreground and lower part of the sky. Once dry, a sky wash of Winsor blue (green shade) was introduced from the top, with the merest hint of Winsor red added. The terracotta colours are a mix of yellow ochre and Winsor red, while the greens are various mixes of Winsor yellow and Winsor blue (green shade) with touches of the other two colours in the palette.

Earth palette

Yellow ochre

Yellow ochre is a golden yellow colour favoured by many artists. It has good covering power and is reasonably transparent in fluid washes.

Light red

This is essentially yellow ochre heated to a darker tone during manufacture. It shares the same qualities but is more terracotta in colour.

Prussian blue

This is similar to Winsor blue (green shade) in that it has a very powerful influence on the painting.

Warm sepia

I particularly like Daler Rowney's version of sepia, it is called Warm Sepia and it is somewhat richer than other versions that I have tried. It is ideal for doing monochrome pictures.

Earth palette

An unusual palette, the colours used here were chosen to bring about the harmonies of light red, yellow ochre and sepia. Prussian blue was added as our primary blue for sky washes and shadow glazes. Just for this experiment, I have combined these three colours with the aim of producing a harmonic result.

Earth colours are used in most palettes to provide more natural colours, which are particularly useful in landscapes, but also seascapes and other natural views. It is unusual to have a whole palette of them, as they tend to be less vibrant than colours such as the pure transparent colours on pages 20–21. However, using a palette of only earth colours is an interesting experiment, and will produce a restful, harmonic painting such as that shown opposite.

Opposite:
Over The Hill

After initial washes of yellow ochre were applied over the lower part of the painting, little touches of light red were added to yellow ochre for the lower part of the sky. With the addition of Prussian blue, the sky colour was brought into the top part wet into wet.

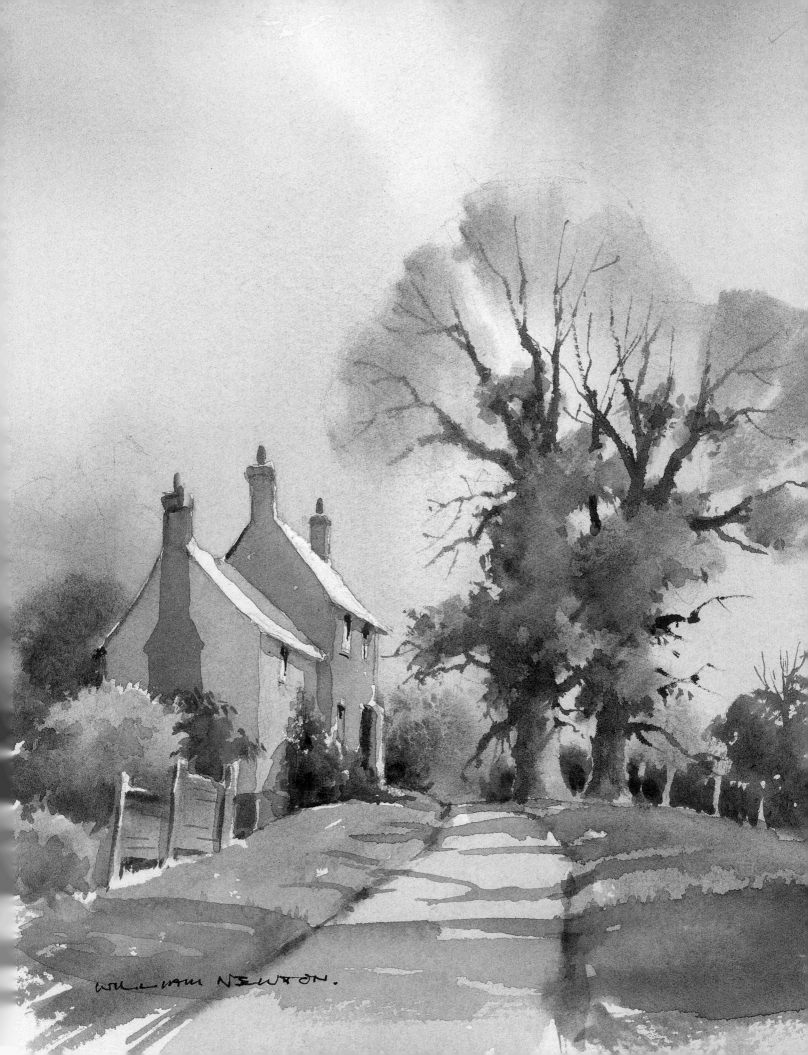

WILLIAM NEWTON.

Mixing colours

More than any other medium, watercolour requires forethought and a certain amount of planning before applying paint to paper, since making alterations and correcting mistakes is not always easy.

Consistency

Using a large mixing space on your palette or a large white soup plate, squeeze out some paint on to the edge, dip the brush into water and bring some of the pigment into the well of the plate and mix it thoroughly. Adding more pigment will make the mixture darker, while adding more water will lighten it.

In other words, the relative pigment to water ratio has to be learned and practised. When you do mix a pool of liquid watercolour, make sure that it is mixed completely from the brush as sometimes with some of the more sticky colours like cobalt blue, a little bit of undiluted pigment will stick in the brush and will smear on to the paper and be difficult to wash away.

Applying paint to paper

It is best to test your colour with a brushstroke on a piece of scrap paper. A sometimes frustrating feature of watercolour is that it dries considerably lighter than when applied, with some loss of tone. With experience you learn to compensate for that by applying it a little darker.

It is well worth using a sheet of watercolour paper to experiment and practise upon, trying washes wet into wet and then wet on dry. Try adding a second colour to the first and mixing on the paper wet into wet, then try the same process wet on dry. A word of warning: both wet into wet and wet on dry are fine, but wet on damp is difficult and may produce a backrun (see right).

Mixing on the paper

Mixing colours on the paper is particularly useful when painting such things as rounded and spherical objects, portraits and animal pictures. It is also useful when painting foliage in order to show light on one side and shadow on the other.

Water control is important. In painting a tree, for instance, I would use plenty of water in the first light washes and less water when adding the darker tones for the shadowed side.

Tip

You should only add colour when the paper is still wet – if it is merely damp, a wet mix will lift the semi-dry pigment and cause a backrun as shown above, sometimes called a 'flare' or 'cauliflower'.

1 Wet your paper and brush, then pick up your first colour on your brush and lay it on to the paper.

2 Rinse your brush, pick up your second colour, and lay it on to the existing colour. Do not scrub it in; the water will carry the pigments into one another. Note how the colour bleeds in. Experiment with different levels of dryness for different effects.

3 While the paint is wet, you can add more of the pure paints to strengthen one colour or the other.

Mixing on the palette

If you want a colour to remain consistent for a large area, such as a sky or when blocking in architectural subjects such as walls and roofs, mixing on the palette is useful as it allows you to check the exact hue before it is applied to the paper.

1 Squeeze a small amount of your colours from the tubes on to the palette, far away from each other. Dip your brush in clean water to dampen it, pick up a little of the first colour and place it into the centre.

2 Rinse the brush, pick up the second colour and draw it from the edge of the palette into the first colour. This creates a range of hues from the pure colour to the mix.

3 You can add more water for a more dilute mix, or add in more paint for a stronger mix.

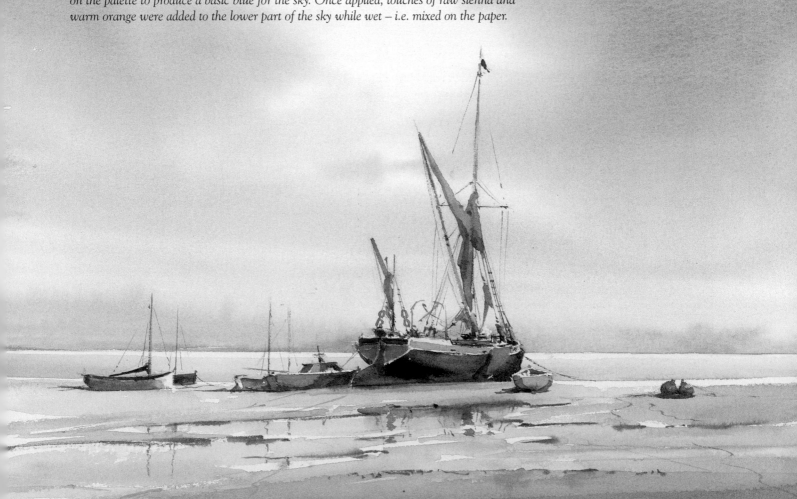

Tide Out

The sky of this coastal scene was made up of four colours: French ultramarine, Prussian blue, warm orange and raw sienna. The French ultramarine and Prussian blue were mixed together on the palette to produce a basic blue for the sky. Once applied, touches of raw sienna and warm orange were added to the lower part of the sky while wet – i.e. mixed on the paper.

Mixing greens

When I require green colours for pictures involving foliage, I like to mix my own. This is because I have not found any ready-made greens that look like the natural colours of the landscape. A frustrating point for the art tutor is that some ready-made palettes of colours that students have bought will be full of far too many blocks of unsuitable colours, with four or five greens, plus a black and a white, none of which are of much use.

My green mixes are usually based on various yellows mixed with blues. Occasionally, I may add a third colour such as burnt sienna or burnt umber. Of the mixes shown in the examples below, lemon yellow figures strongly and is really a pale sharp green. When used with just a touch of French ultramarine, the resultant mix is excellent for sunlit grass, lawn areas and so forth.

Lemon yellow.

Lemon yellow (top) and French ultramarine (bottom).

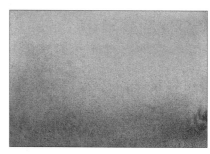

Cadmium yellow (top) and cobalt blue (bottom).

Lemon yellow (top) and cobalt blue (bottom).

Raw sienna (top) and French ultramarine (bottom).

Cadmium yellow (top) and Prussian blue (bottom).

Lemon yellow (top) and Prussian blue (bottom).

Raw sienna (top) and Prussian blue (bottom).

Burnt umber (top) and Prussian blue (bottom).

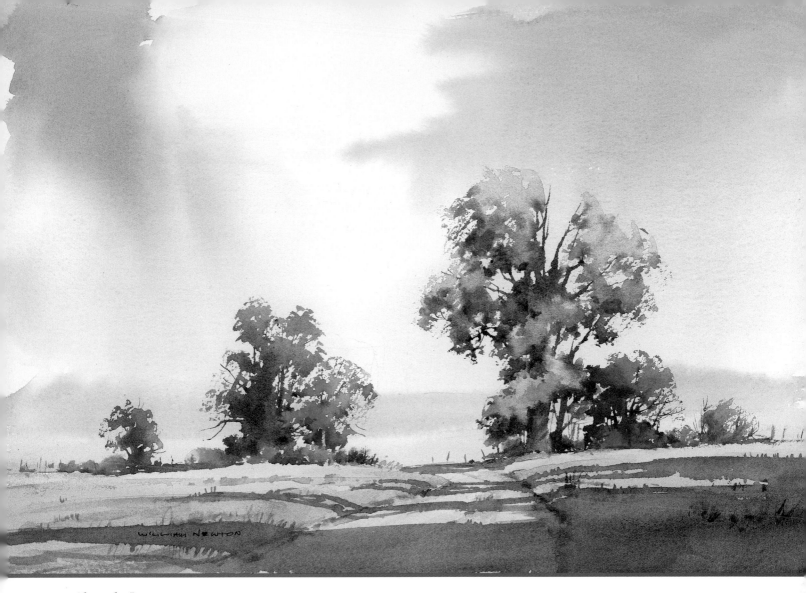

Along the Lane

This picture was painted specifically to demonstrate the mixing of greens with as much variety as possible. All of the greens here are mixed with combinations of various blue and yellow paints. I find that greens made in this way look much more natural than any ready-made ones.

The pale areas here were initially laid in with lemon yellow dry brush work. When dry, these light-toned areas were shaped and sculpted with a pointed brush using a darker mix of French ultramarine and raw sienna.

The darker green here was made with cobalt blue and just a little lemon yellow, while the brighter foreground green was painted with raw sienna and a touch of French ultramarine.

Here, Prussian blue and cadmium yellow with a little burnt umber have been used for a rich green.

Tone

Light, and the depiction of it, is fundamental to watercolour painting. In order to paint light, one must understand and learn about tone and how to fully exploit tonal values within a painting. In this respect one learns that tone is quite a different thing from colour, that the colour of any element in a picture is what the light is making it – or rather, what the light is allowing it to be.

How to paint light

Wouldn't it be wonderful if one could buy a tube of light? The irony is that light is created and represented in a painting by observing and depicting shadows. One applies a brush loaded with a 'shadow mix' in order to paint light! The actual colour of an element within a scene may be irrelevant. For example, a roof which has black or dark-coloured tiles may be left as white (or almost white) paper in a watercolour if the light is coming from a certain angle. An example of this can be seen in *Tugboat on the Thames* on pages 30–31. Furthermore, since we are painting on a two-dimensional surface we may need to adjust or exaggerate part of the painting tonally so that the scene appears three-dimensional and compositionally effective.

Tones give emphasis to areas of the painting. It is worth noting that the area of the picture with the strongest tonal contrast will probably become the focal point (see pages 54–55), so we need to use this knowledge to structure the painting. For example, we can arrange our tonal composition along the sound principles of the rule of thirds (see pages 52–53), with the greatest contrast in tones along the intersections. The brightest light we have is the untouched paper, but perversely, areas warmed by a very dilute wash of raw sienna or similar can look brighter than pure white paper.

If I am painting outdoors or using a piece of reference such as a sketch or photograph, the area where artistic licence is most likely to be employed will be in adjusting tones; creating contrast around a light-toned roof by adding dark trees or foliage around it, for example.

In confined areas such as interiors, light can bounce. A good example would be a portrait where light rebounding from a nearby wall partially illuminates the shadow side of the face.

In summary, the direction of the light source is all-important, but with experience and using artistic licence, you can have the light source where you want it to be. It is worth doing small sketches in pencil or watercolour with light coming from different directions (see page 45 for examples of this) to see which one works best.

Tip

Contrasts do not have to be extreme. We may not need black against white to draw the eye – two tones can be closer as long as it works visually.

Opposite:
Barge Skipper

Standing at the helm, the captain's spectacles, parts of his face, hands and clothing are bathed in bright light. To achieve this, parts of the painting where bright light is falling on the scene are left as almost pure white paper. The ship's wheel is also mostly white paper, despite being made of dark hard woods.

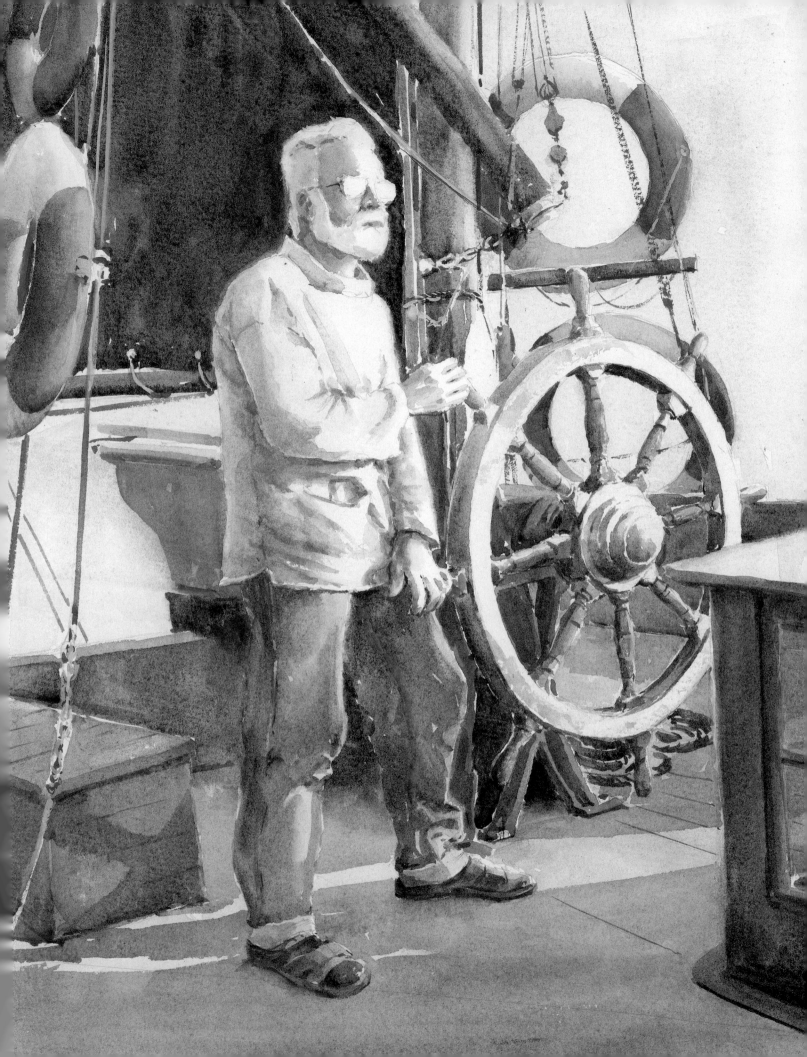

Tone and distance

Watercolour differs from other media in that the tonal values are lightened and reduced only by the addition of water: different dilutions will produce different tones.

Objects lose strength of tone as they get further away, owing to the effects of the atmosphere (see aerial perspective on page 59). Both light-toned and dark-toned objects lose their intensity, becoming greyer and weaker.

This does not mean that we should not take pleasure in the use of wonderful bright colour in the foreground – if needed, of course – but in order to represent distance, the tones of the colours in the distance must become weaker in order to ensure that the scene looks three-dimensional and compositionally effective.

I tend to exaggerate this effect by using cobalt blue in background mixes to give the impression of distance – because of course the paper itself is two-dimensional, and we are attempting to simulate the depth of a three-dimensional image.

The area with the strongest contrast in tone will probably become the focal point. Bearing this in mind, the stronger tones in the foreground mean that it is easier to create a focal point here, rather than in the softer tones of the background.

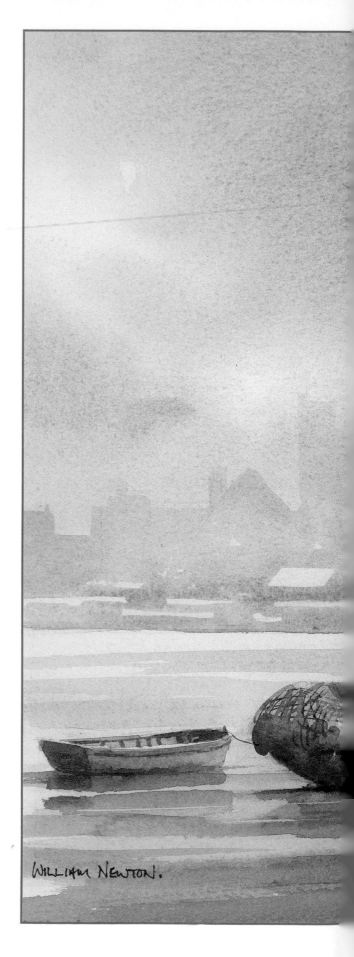

Tugboat on the Thames

This is a studio painting that was produced in an unusual way. The tugboat itself is an old World War 2 steamer called The Brent, *which I have drawn and painted many times. Its tall funnel is very much part of the riverside scene at Maldon (Essex, UK).*

The boat was drawn in first using a 2B pencil, and in the background a straight line was drawn in lightly from side to side to represent the far waterline of the river. The buildings of the completely invented skyline were then painted with a 12mm (½in) flat brush, cobalt blue and a little burnt sienna. Second washes of the same colours were added wet on dry to loosely suggest details such as roofs catching the light. After these were dry, sky washes of French ultramarine, burnt sienna and a little cobalt blue were washed down over the buildings down to the waterline, to create an atmospheric effect, putting extra tone into the cloud design behind the tugboat's funnel in order to bring about a tonal counterchange.

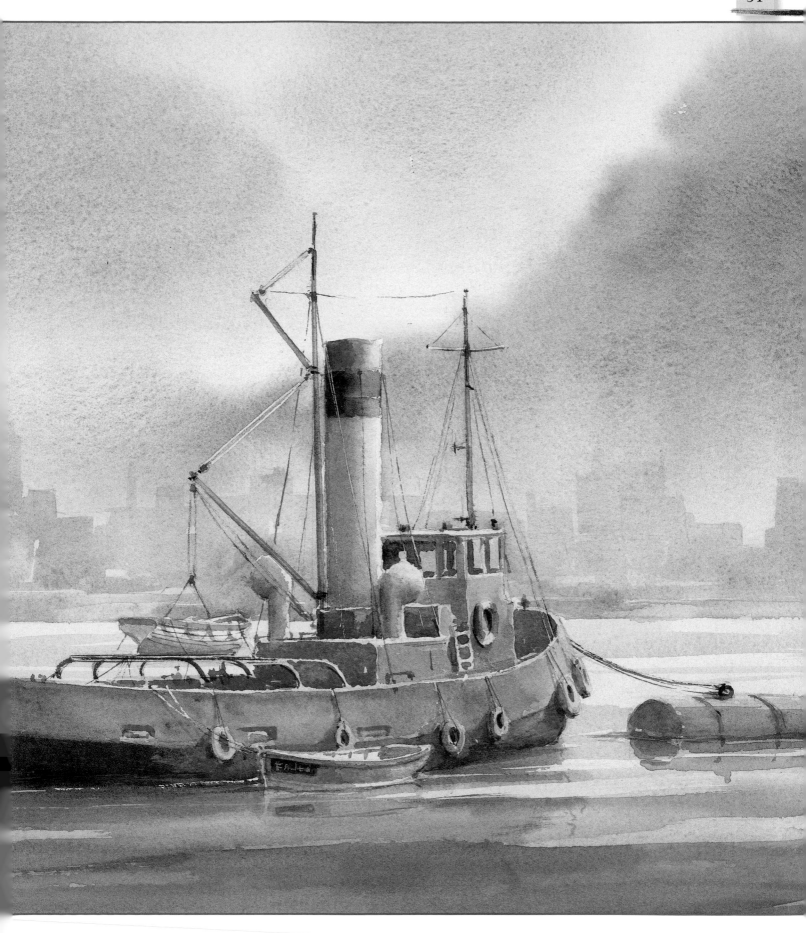

Shadows and glazing

Light is a constant preoccupation in my work, and light in a painting is created by shadows. The observation and placement of shadows is therefore arguably the most important part of a watercolour since it enables the elements of a picture to be united, linked together, and given a three-dimensional look. It also helps to establish the source of light. Shadows make a scene much more interesting. In order to produce good artwork, one should spend a great deal of time studying shadows and the way they fall – sometimes with hard and sometimes with soft edges.

Watercolour painting could be said to be a layer by layer process – the picture is built up from overlaying semi-transparent washes of colour in specific areas. It could be argued that each area requiring darkening should be separately mixed but that is unlikely to bring a good outcome as it could look patchy and overworked. A better solution is to make one shadow mix to use throughout the work.

A common mistake is to mix too many pigments together for the shadow glaze. Because the shadow mix is applied over dried layers of other mixed colours, using too many pigments in your shadow glaze may produce a muddy, opaque result. The mix I use is usually diluted French ultramarine, occasionally with a touch of orange or similar colour to neutralise it.

I think of my shadow mix as a converter: I use it to convert the various coloured elements of a picture to a shadowed version of what they were. The shadow glaze is normally applied as the final part of the work in one co-ordinating operation.

With rounded forms such as on the statue of Peter Pan (opposite), a different technique or mix of techniques is used. Here the lights and darks are blended wet into wet and gradually layered, with the final touches added wet on dry, in the shadowed areas. The same techniques can be used for portraits, animals, some trees, and round buildings such as lighthouses and oasthouses. In fact, this technique can be used for round or spherical things in general.

In this detail multiple layers of a French ultramarine and burnt sienna mix have been built up in the small of the back to create rich, deep shadow.

The same French ultramarine and burnt sienna mix has been used to form the dark shadows at the top of the legs and contrasted against the scalloped edge of the tunic, which, in catching the light, is left mostly as pure white paper.

Peter Pan Statue

This beautiful little statue is in Kensington Palace Gardens, London. It is the work of the sculptor Sir George Frampton and was commissioned by the author of Peter Pan, *J. M. Barrie. The statue was erected in 1912.*

A charming story has it that the statue was cast from melted-down pennies donated to Great Ormond Street Hospital. As a painting subject it is an exercise in using a very limited palette of raw sienna, burnt sienna, French ultramarine and a little lemon yellow. Blending of tonal values is used to show modelling of the figure with hard and soft edges, varying the tones to achieve a three-dimensional effect. Statues make good models – they keep very still!

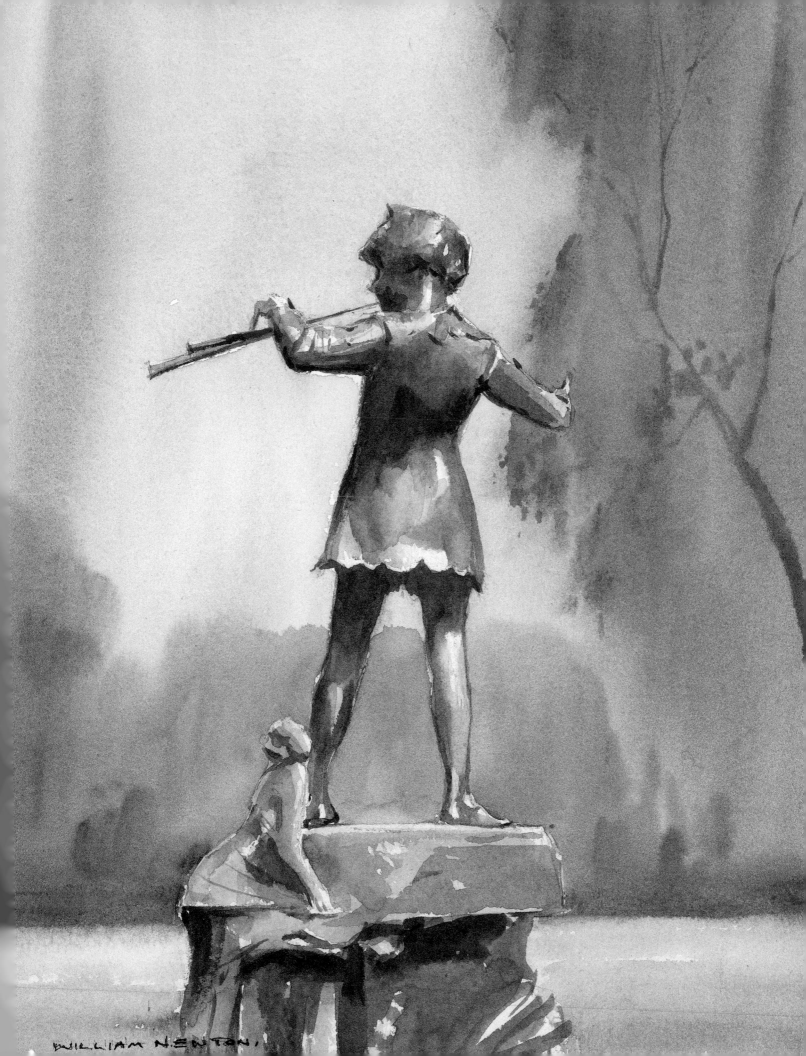

WILLIAM NEWTON.

Tonal exercise – Framlingham Castle

Although monochrome painting can be thought of as a beneficial exercise to study and learn about tonal values and dilution of watercolour pigment, tonal composition, contrast and counterchange, there is no reason why a single colour painting cannot stand alone as a finished work. Some subjects lend themselves very well to monochrome, such as evening scenes and river scenes.

This step-by-step exercise demonstrates how effective a single colour can be in producing an atmospheric painting, as long as careful attention is paid to the tonal values.

You will need

Saunders Waterford 300gsm (140lb) rough paper, 38 x 28cm (15 x 11in)

Brushes: 37mm (1½in) flat synthetic, 25mm (1in) flat synthetic, size 12 round, size 6 round, size 2 rigger

Colours: Van Dyke brown

Picture tape

2B pencil

Putty eraser

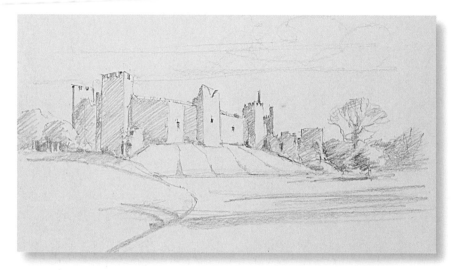

The tonal sketch for this exercise.

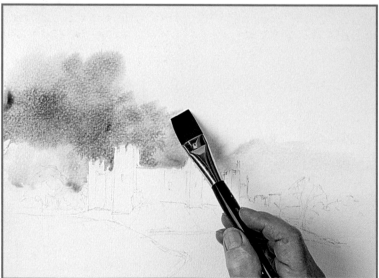

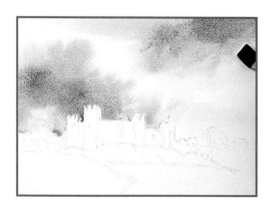

1 Draw the basic lines with a 2B pencil, then use picture tape at the corners only to secure it to your board. Dip a 37mm (1½in) flat brush in water, shake off the excess and wet the whole sky down to the horizon, working carefully around the castle. Change to a 25mm (1in) flat brush, and pick up some dilute Van Dyke brown. Work it in wet into wet across the top of the castle, then lay in more paint on the left to reinforce the area.

2 Add an area of tone at the top right to lead the eye back into the painting. Pick up the board and tip it to encourage the paint to move and hide any brushtrokes.

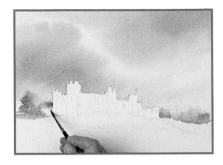

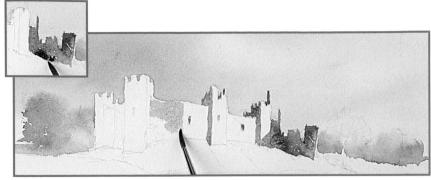

3 Change to a size 6 round brush and begin to place trees in the background using the tip of the brush to suggest a little texture. Allow to dry.

4 Working from top to bottom, paint in the silhouetted background part of the castle on the right-hand side with a fairly strong tone of Van Dyke brown (see inset). Leave a few gaps of clean paper for interest. Begin to paint in the left-hand sides of the towers with a mid-tone – the light source is on the right, so these parts are in shadow. Use a more dilute mix for the kinked curtain wall, as this is only in partial shade.

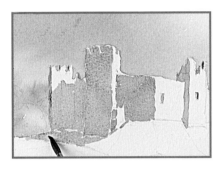

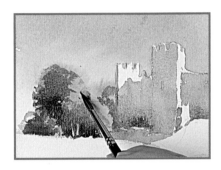

5 Paint the shadows on the left-hand side with the mid-tone, including the shadow cast on the hillside. Leave a glimmer of clean paper on the right-hand sides of the battlements.

6 Develop the shading on the trees by overlaying the mid-tone over the existing shape on the left-hand sides. Use the tip of the brush to suggest texture and the trunks using negative painting.

7 Use the dry brush technique to paint the large tree on the right-hand side, drawing the lightly loaded brush over the surface of the paper. Change to a size 2 rigger and paint in the trunk and main branches with broken lines.

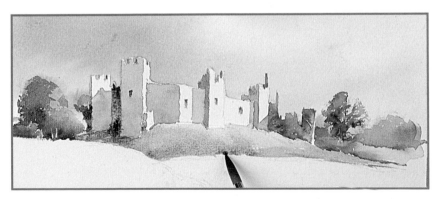

8 Develop the scrub and bushes around the background on the right-hand side with the size 6 round.

9 Reinforce the shadows on the castle using a glaze of a more dilute (i.e. lighter-toned) mix. Change to the size 12 round brush to apply the lighter-toned mix over the hillside that the castle sits upon. Vary the tone to add some modelling to the hillside while the paint is wet.

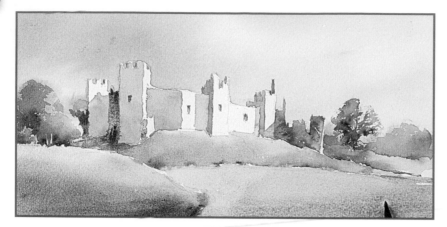

10 Paint the foreground hillock on the left-hand side with washes, using very slightly darker tones than the hillside. Use the same tone to paint the rest of the foreground, diluting it slightly where the foreground meets the hillside, then reglaze the hillock and extreme foreground to darken them.

11 Use the tip of the size 6 round with a dark tone to develop some details around the castle and to reglaze the background trees on the right-hand side, using negative painting to suggest the trunk of the large tree.

12 Allow the painting to dry completely before continuing. Use the tip of the size 6 round and the size 2 rigger to add some details across the painting using the dark-toned mix. Change to the size 12 round and lay in a glaze of the mid-tone mix over the foreground. This shadow will lead the eye into the painting.

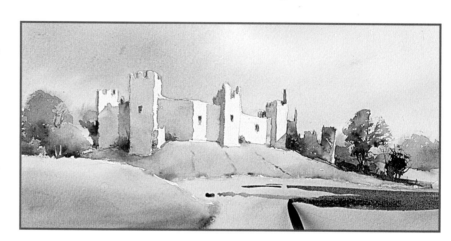

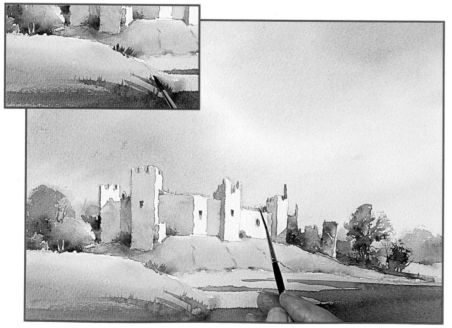

13 Continue the shadow over the foreground to the left-hand hillock, following the shape of the ground with your brushstrokes. Use the tip of the size 6 round to lightly bring the wet paint upwards to suggest the texture of grass on the hillock (see inset). Add any final details, such as the handrails on the castle walls, using the size 2 rigger and the light-tone mix, then allow to dry.

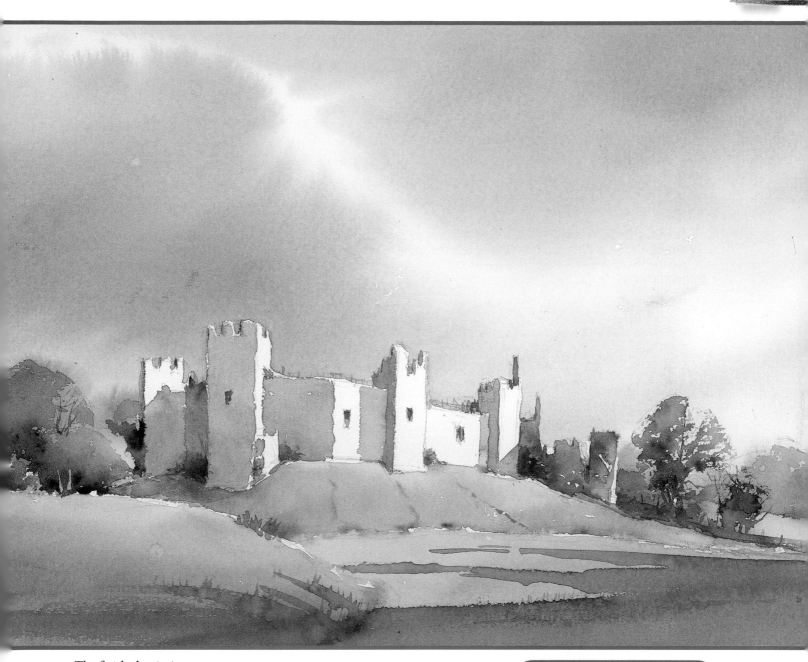

The finished painting

You might like to try this project with different colours. Warm sepia and burnt umber are excellent for the job, but almost any colour can work. Using a blue may produce a convincing moonlit scene, for example. Anything can be tried; I would always encourage a spirit of experiment! Remember the level of tone is achieved by varying dilution with more or less water.

You can try a monochrome on tinted paper – try Van Dyke brown on cream or French ultramarine on pale blue. Furthermore, there is no reason why a second warm pale colour cannot be glazed over a dry monochrome although you would need a good quality paper, such as Saunders Waterford, which will hold the first dry wash better because it is more lift-resistant.

Tip

A good way to see how well your full colour paintings work tonally is to photocopy them in black and white and thus see them as monochromes.

Techniques

In my regular workshop classes I usually set a piece of work that will evolve into a finished and complete picture, into which I try to build in lessons in painting technique. For example, there may be buildings that will involve blocking in or glazing, tree branches or rigging that require the student to paint fine lines, or fabrics or skies that require working wet into wet.

The following pages demonstrate some of these essential techniques as very simple exercises. The more you practise, the better, and I encourage you to learn these techniques through simple exercises like painting balloons, cups or other rounded forms, or practising your wash techniques by painting skies and lakes.

Graded wash

This is an exercise in bringing down a graded wash starting with a strong blue pigment which is progressively diluted as the brushwork is brought down. This technique is useful for skies and other large areas. You may hear it being called a graduated wash – this is simply another term for the same technique.

1 Set your board at a slight angle, then pick up some slightly diluted paint on your 25mm (1in) brush and draw it across the paper in a broad horizontal stroke. The wet paint will gather at the bottom of the stroke owing to the tilt.

2 Without reloading the brush, draw it across the paper again, overlapping the bottom of the previous stroke to pick up the bead and ensure good coverage.

3 When your paint begins to run dry, pick up a more dilute version of the paint and repeat from the lowest stroke you reached. Continue down to the bottom of the area.

Wet into wet

In the second exercise, the same process is carried out, but this time wet into wet mixes of other colours are added on the way down. This exercise shows how useful this technique is for painting skies at dawn or dusk, but the basic principle of adding paint to wet areas is useful for creating soft graduations, as shown in the study below.

1 Lay in a wash over the area with your first colour, exactly as for a graded wash.

2 While the paint is still wet, pick up your second colour and lay it in to the existing colour. Here I am grading the colour from one to another, by drawing it across in horizontal strokes.

3 Continue in the same way; adding extra colours as needed. The critical point is that the paper must remain wet – do not be tempted to continue if it has started to dry.

Norfolk Fisherman

In this study of a Norfolk fisherman, the paint was applied quickly and freely. Most of the jacket was painted wet into wet with the darks added progressively. Very dilute paint was used on the top of the shoulders and hat, allowing much of the white paper to show through.

As the paint dried, more darks were added to represent creases on the sleeves and lower back, and the same techniques were used on the long wader boots. The effect I wanted was a mixture of hard and soft edges.

A weak mix of cadmium red and raw sienna was used for the face and hands.

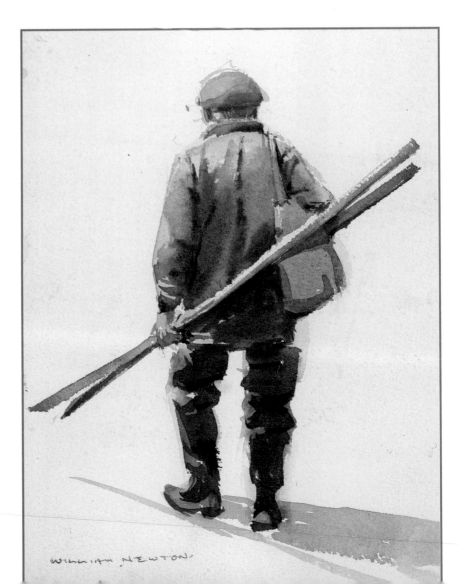

Blocking in

When working into a hard-lined shape, use a flat brush as this makes it easier to work up to the edge.

1 Using a 12mm (½in) flat brush, wet the area you want to fill with colour.

2 Pick up your colour and drop it into the wet area. The colour will only flow into the wet area, stopping at the dry edge. Use the edge or blade of the brush to work neatly up to the edge.

3 Continue to fill in the shape by laying in more colour.

Negative painting

I think of this technique as being similar to sculpture – the base colour (green in this example) is the stone, and your brush is the chisel. You are aiming to shape the foreground details by 'cutting away' the background.

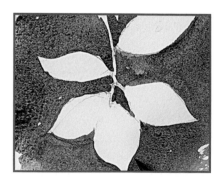

1 Pick up some slightly diluted paint on a 25mm (1in) flat and lay in a wash over the whole area. Allow the wash to dry thoroughly before continuing.

2 Pick up a contrasting colour (or simply another layer of the original colour) on a smaller, more controllable brush and lay it into the background behind the positive shapes (the leaves, in this example). Work carefully around your pencil lines.

3 Continue until you have filled the background. Notice how the positive shapes, remaining lighter, seem to advance.

Fine lines

For fine lines the rigger brush is an essential tool. It can be used in many ways, from lines and cables on ships to branches on trees. It might also be used for suggesting hair on portraits of animals or people.

1 Load a rigger with your paint and be ready to place it where you want your line to end.

2 Draw the rigger across the paper for a straight line.

You can draw curves and bends with this technique – simply keep drawing the tip of the brush across the paper. Because the rigger holds a lot of paint, you can draw long fine lines easily.

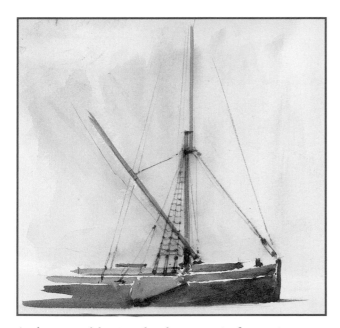

As the name of the rigger brush suggests, its first use is to depict rigging in boat pictures. To do so, run the ferrule of the brush along the high side of a ruler held at forty-five degrees to the paper surface.

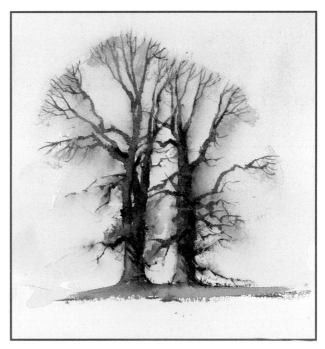

The second use for the rigger brush is for painting tree branches. Here the brush was pulled along, and the downward pressure varied to make the required tapered shape. The ruler is not used for lines like this; any study of trees will show that branches deviate and bend this way and that. Oak tree branches are all knees and elbows!

Dry brush work

The name of this technique is a slight misnomer. The brush is loaded, but not too heavily. I sometimes call it dragged brush work, as the technique relies on drawing the brush lightly over the surface and picking up the texture of the paper.

1 Load your brush as normal, then wipe off some of the paint on some kitchen paper.

2 Hold the brush and draw the side of the brush lightly across the surface of the paper.

3 Repeat as necessary to build up interesting texture within a shape, or freehand.

Masking

Using masking fluid enables you to apply your washes freely across the masked areas, which is useful when intricate detail needs to be retained. Be aware that the masking fluid can act as a dam and create pools of paint in enclosed areas. Make sure the wash is even all around the masking fluid in order to ensure that it dries evenly all across the area.

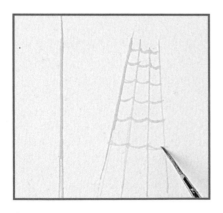

1 Pick up masking fluid on your brush as usual, and draw the parts you want to remain clean in the final painting.

2 Allow the masking fluid to dry, and then you can paint straight over the top.

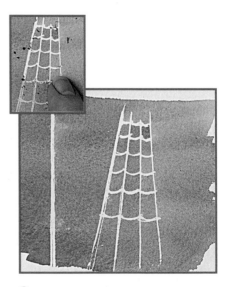

3 Leave the paint to dry, then use a clean finger to gently rub away the masking fluid (see inset), revealing the clean paper.

Pen and wash

Pen and wash techniques, as a derivative of watercolour painting, could fill many books as a separate subject. One of the most enjoyable ways to use watercolour, the pen and ink are used in conjunction with colour, mixing the crispness of pen and ink with the loose transparent qualities of watercolour.

I often like to draw directly with the pen with no prior pencil work or rubbing out. This can improve one's drawing since one needs to think carefully before drawing each line knowing it cannot be erased.

Occasionally, one might add further touches of pen work after the watercolour has been done. Also, using the pen on a normally painted but indifferent watercolour can turn it into something rather special in which case it might be called wash and pen! Pen and wash can be a very flexible way of producing artwork and there are lots of different styles as well as variations in equipment used.

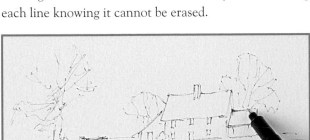

1 Use a fine pen to place your initial lines. Aim to work freely – searching for the line (i.e. the additional lines before you hit the right spot) adds character and motion to a piece.

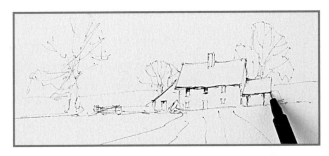

2 Broader nibs are useful for placing thicker details and reinforcing lines that would cast shadows, such as under roofs.

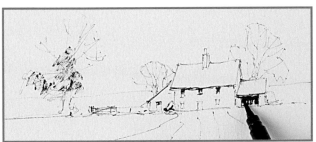

3 A brush pen is fantastic for larger areas of tone without being solid black. Use them much as you might a brush – you can try techniques such as dry brush work with them.

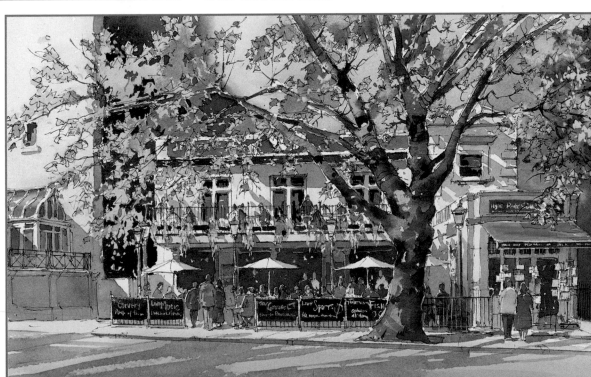

The Swan Tavern, Bayswater

This pen and wash painting was completed on the spot. It is a wonderful subject, full of life, light and sunshine supported by a beautiful London plane tree.

Choosing your subject

When choosing your subject, it is important whenever possible to sketch trees, buildings, people, animals, boats, ships, still life and anything else you want to paint by making sketches from direct observation. If you are drawing for a painting on watercolour paper, it is important to keep the pencil work light and minimal. I suggest using a 2B pencil.

When sketching, I often work directly with a brush using very dilute raw sienna to draw my picture. This is a different way of working that produces a softer result.

What to sketch

Whilst admiring past masters, I try not to be sentimental about my choice of subject matter. I do not think it is looking at the past with rose-coloured spectacles to say that I greatly envy artists of a hundred years or so ago who were blessed with such wonderful subject matter. It is not nostalgia or sentiment to say that clothing (especially ladies' wear with those lovely elegant hats), architecture, horse-drawn vehicles and clipper ships were simply more aesthetically pleasing and paintable than some of today's equivalents.

Of course, subject matter can be very personal. You may have special interests: themes such as railways, aircraft, cars, flowers, animals and portraiture come to mind. But there is a danger in putting too much of what you know into the painting making it look laboured and overworked; far better to just suggest details than to put in too much. A good motto would be 'careful carelessness'.

Whatever the subject, I believe in going about it in essentially the same way. That is, with good close observation, good drawing and simple fluent watercolour painting. Putting into it all the good technique we have learned (and we should never stop learning!) to not only depict the chosen subject but to say something of ourselves in the way we translate it on to paper.

If you are just starting to paint in watercolour, it is best to keep the composition simple by keeping that focal point cottage at some distance, by painting the portrait in profile, or that boat picture as a side view and then progress from there.

Sketching: light

Any subject that you choose can be sketched or painted at any time. Nevertheless, there might be an optimum time depending on the position of the sun, and it is here that the benefit of drawing quick tonal thumbnails with the shadows hatched in becomes obvious. Three sketches of the same landscape, at different times, are shown below.

Any of the three examples would work as a finished painting, but overall I think the afternoon light produces the nicest result. Notice how the tones of the trees on the left are used to bring about counterchange against the building. Try returning to promising locations with your sketchbook over a few hours or even days to find out what time works best.

Morning

Here the light is coming sharply from the right, illuminating the front and the roofs of the cottage with long shadows cast from the right-hand side to the left-hand side of the scene.

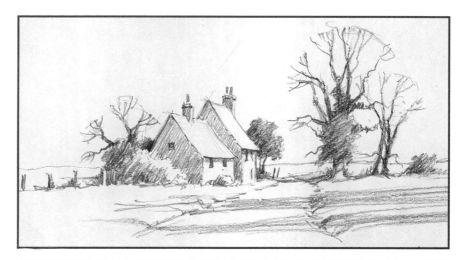

Midday

Here the sun has moved above us with the light coming a little towards us.

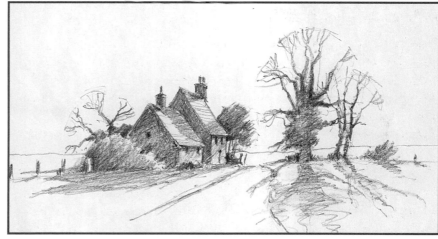

Afternoon

Now the sun has moved over to the left of the scene, darkening the roof and front of the cottage with shadow from left to right.

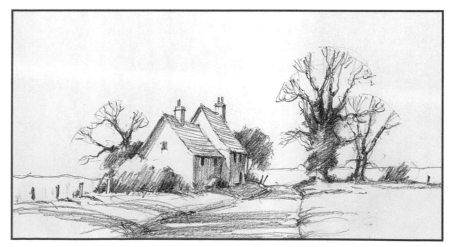

Sketching: tides

Similar principles to light changing throughout the day apply to the moving water levels in tidal settings. Again, the benefit of quick sketches is clear when painting marine compositions.

With experience you will be able to paint pictures with moving elements, such as open water or moving light, fixed firmly in the mind. When you are starting out, you may wish to minimise the changes by sketching tide-out pictures, while the boats and water keep still.

As on page 45, the examples below show the same composition at different times. Either sketch could make a good picture but do not fall into the trap of sketching a river scene with boats at different levels: time and tide wait for no man – in other words everything moves!

Tip

Using your camera is an excellent way to capture a particular moment in time. As you progress, you may find that you prefer to work from life in order to build your skills at working quickly and enjoying the particular atmosphere of a place.

Tide out

Here the tide is out – the dinghy is on the mud and tilted over. You can see the inside detail as well as puddles of water left by the retreating tide.

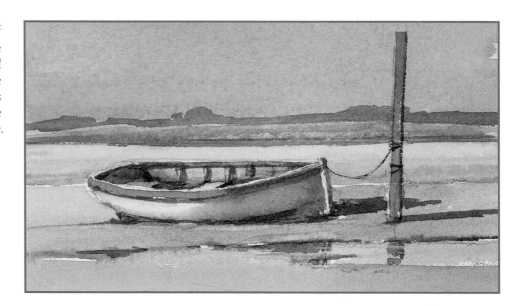

Tide in

Now that the tide is in, the boat is now floating. From the same eye level, we can no longer see inside the boat; and it has obscured the horizon level a little.

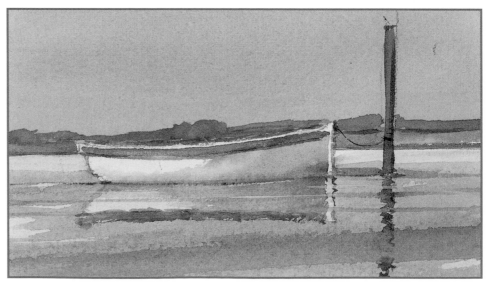

Sketching: different angles

When you are on location, make the most of your visit by gathering as much visual information as possible. Sketch things at different angles – there may be an optimum angle that shows the subject as its best, but it may well be that the same subject can be used for a number of different paintings: I often think that a good subject deserves more than a single painting.

While this is true of all subjects, it is particularly true of people. Whether for a particular portrait, or simply as a genre painting including figures or faces, it is important to sketch people from as many different angles as possible.

This page shows a small selection of people from my sketchbooks.

Using photographs

With the invention of photography and the camera in the 1830s, a wave of depression swept some artists of the day. On seeing some of the first photographs, the French painter Paul Delaroche said, 'From today, painting is dead'. With the benefit of hindsight he was, thankfully, wrong.

I am an enthusiastic photographer and do not believe that photography and painting need to be competitors. The camera itself, for all its modern sophistication, is only a dumb recording tool and will only record what it is pointed at. Subsequent painters in the following years have embraced the camera as a wonderful piece of apparatus for gathering reference. It is very good at catching that fleeting moment of light or positions of shadows which are not always easy to remember or imagine.

I think of the camera as a sort of electronic sketchbook. I love painting *en plein air* but there is not always time available and there are occasions where the best composition is from somewhere it is impossible or impractical to set up an easel, such as the middle of the road! Other uses for photographs are for moving objects, and portraits of animals and children.

However, we should not be just copying photographs, we need to put something of ourselves into the work and to exploit the very beauty of the wonderful watercolour medium. Furthermore, for all the usefulness of the camera, we still need to practise our drawing and to improve our sense of observation to produce work in a creative and satisfying way.

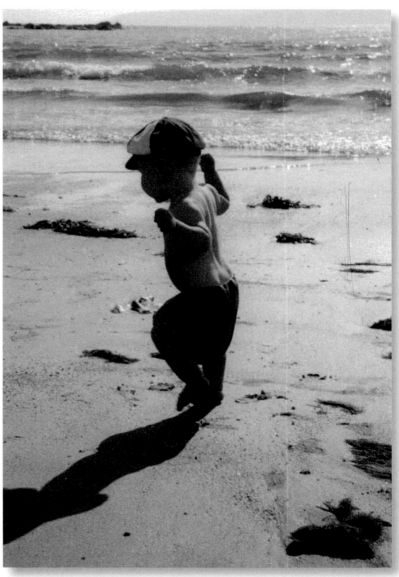

The source photograph for the painting opposite.

Opposite
On the Beach

My intention in this painting was to reproduce the wonderful light in the photograph.

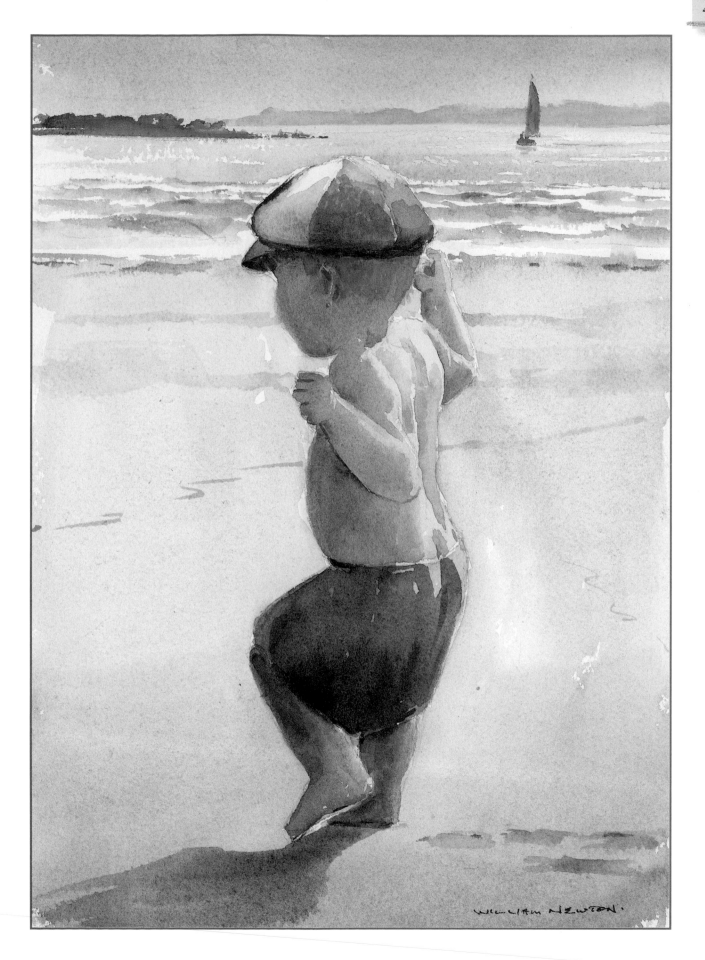

Composing with a camera

It is rare to arrive at a possible painting location to find a scene that is perfect and waiting only to be painted. While I love outdoor painting, I also take the opportunity to gather as much reference material as possible, in the form of sketches and photographs, so that I can consider the best approach for the final composition later in my studio.

When taking a photograph it is best to hold the camera level so as to avoid distortion but this will usually give an undesirable middle horizon. If using a single photograph for reference I usually aim to lower the horizon in any painting based upon it. In other words, I take a bit off the bottom and add it to the top!

On the facing page is an example of *Tide Out at Pin Mill*, a studio painting created from the reference photographs shown on this page. All of the photographs were taken after a sketching and painting trip.

Any of the photographs shown here could be used as a basis for a single barge study but in my painting I have used multiple photographs to create a composition that brings the two barges closer together and places them to the left of the composition. To balance this, the jetty from the lower right-hand photograph was added to the right, and an invented cloud formation was created to complement the overall composition.

If you are using more than one photograph it is important that you unify the composition by having such things as light direction, shadows and level of tidal water the same.

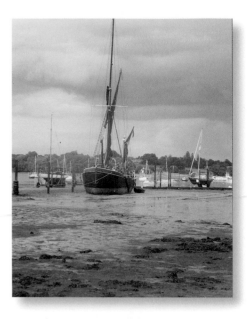

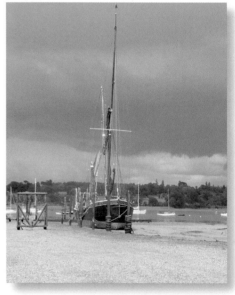

The horizon is too high and the barge too central on the top right-hand photograph, as is the case with the photograph in the centre right. In the bottom right photograph, the horizon is somewhat lower but still crops the top of the mast. In the photograph below the two main boats are too far apart splitting the composition in two.

While any of these photographs could have been used as the basis for a painting, by combining parts from each, a more successful composition can be achieved.

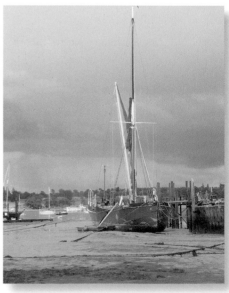

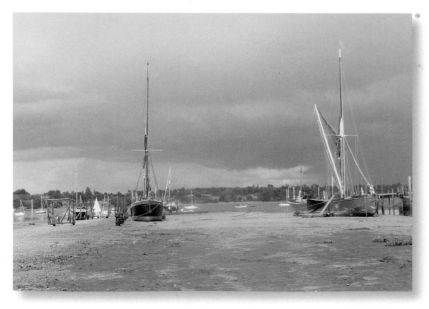

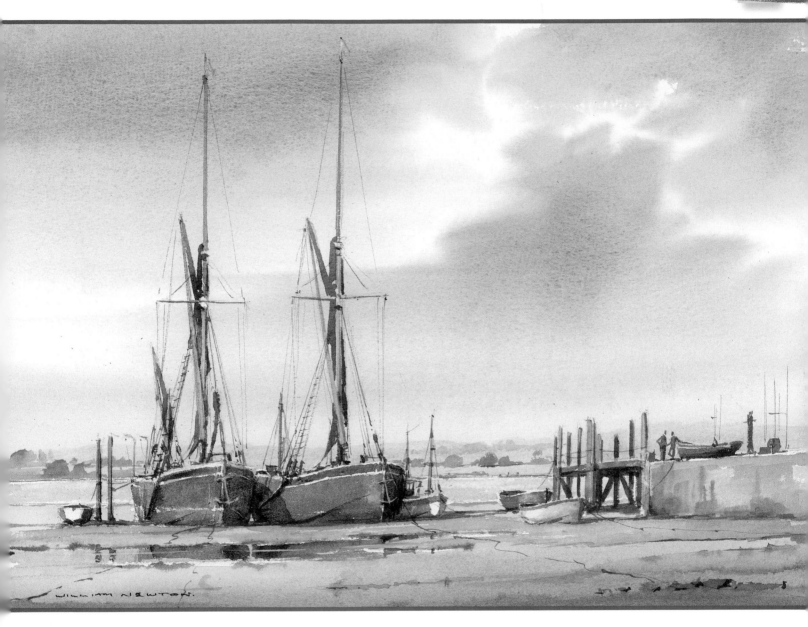

Tide Out at Pin Mill

Of all mankind's inventions, certain landmarks of design stand out as unforgettable iconic shapes which will perhaps never be visually surpassed. One thinks of the Supermarine Spitfire, Concorde and the Jaguar E-Type. Pre-eminent amongst man's creations must be the sailing boat. The beauty of such craft has been an inspiration to artists for centuries. Large sailing ships are now rarely seen and few, if any, cargoes are carried or any commercial fishing now done under sail. However, there can still be found some fishing smacks as well as the redoubtable spritsail sailing barges which, although sadly diminishing in numbers, are now mostly used as pleasure craft.

As subject matter for the artist, the sailing barge has been a great friend. The dark hulls combined with the characteristic red-coloured sails always seem to work very well within a painting.

Composition

Composition is essentially the layout of the picture, and successful composition is when the various elements are organised and arranged so that the finished result is pleasing to the eye and will give lasting pleasure framed on the wall. The following pages will explain a few classic methods of achieving good composition.

Horizon

Placement of the horizon is all-important to ensure the eye is drawn to the most interesting part of the painting. For example, paintings that contain foreground figures usually require a high horizon. Most landscapes, however, require a low horizon with a big sky. These are not hard and fast rules, so experiment with the placement of the horizon in your composition.

The mid-level horizon creates a static, dull painting, with too much emphasis placed on the flat, uninteresting road.

Blue Boar Cottage

In contrast to the example above, this painting has the horizon below the midpoint of the painting, which means the building, sky and trees play a more important role.

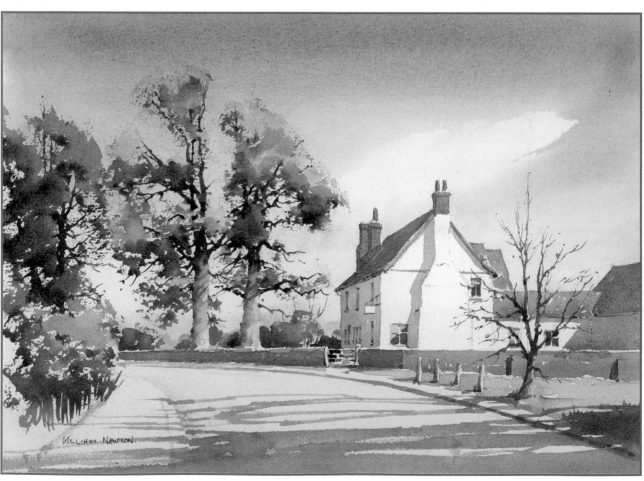

Rule of thirds

A common mistake I see as a tutor is for the student to place the horizon too high across the composition. A good plan in painting, particularly landscape painting, is to stick to the age-old rule of thirds. This suggests that you imagine the painting divided into nine equal parts (see the diagram on the right).

By aligning important parts of the painting with these lines and intersections, you will create a more dynamic, interesting painting. For a landscape, place the horizon line about one third from the bottom of the picture or one third from the top. Similarly, have the main features of the composition one third from the left or from the right; this may be on one of the vertical lines, or at an intersection.

This rule is not hard and fast, and your compositions do not have to be broken into rigid thirds. It really means do not put important parts of your painting in the middle!

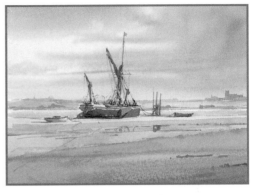

Low Water

This painting has the landscape in the lower third of the painting. The intersections at the lower left and top right contain the boat and cloud formation; two important parts of the composition. As a result, the viewer's eye is led around the picture from area to area.

The placement of the boat dead centre means the eye is drawn there, where it stops. This gives the painting a slightly stagnant, oppressive feel.

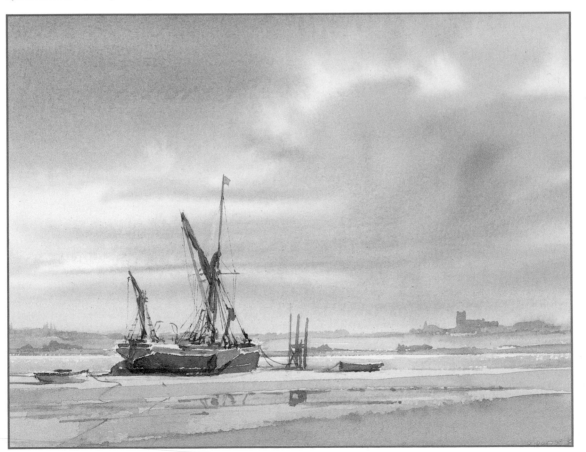

The focal point

The focal point, or points, of a painting are the areas the artist wishes the viewer to concentrate upon; the most important parts of the picture. Compositionally, there are a number of ways of achieving this, though placement, colour and tone.

Strong contrasts, whether in tone (light tints against dark shades), or in hue (particularly complementary colours like red and green, orange and blue and so on) are excellent ways of drawing the eye to a focal point. As discussed on pages 30–31, distance can be suggested by using cool colours and reducing the amount of detail. Conversely, the eye can be drawn to warm colours or to areas with more detail.

Bear these considerations in mind in order to ensure that your focal point remains important within the overall composition. If you use warm colours to draw the eye, be careful about using similar warm colours elsewhere. If using contrast to create a focal point, make sure the contrast elsewhere in the picture is less marked. This will ensure your painting has a strong focal point.

Discussing the Catch

In this watercolour sketch of a fishing boat, the focal point is the boat's cabin. To draw the eye here, strong tonal contrast is used: the dark cabin windows are set against the white cabin itself. Note how this is the most striking area of contrast in the painting – while both light and dark tones are used, none are so obvious as on the cabin. In addition, note the figures adjacent to the cabin (see inset), which add detail and animation.

Country Path

The red clothing of the leftmost figure provides a strong counterchange in this predominantly green painting, and automatically becomes the focal point. The effect is heightened because red and green are complementary colours (see inset).

During the execution of a painting, I take care not to include warm colours or extreme contrasts too near the edges of the composition as this tends to take the viewer's eyes out of the picture.

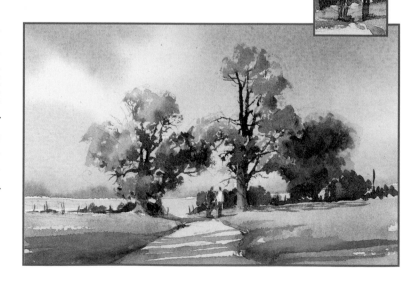

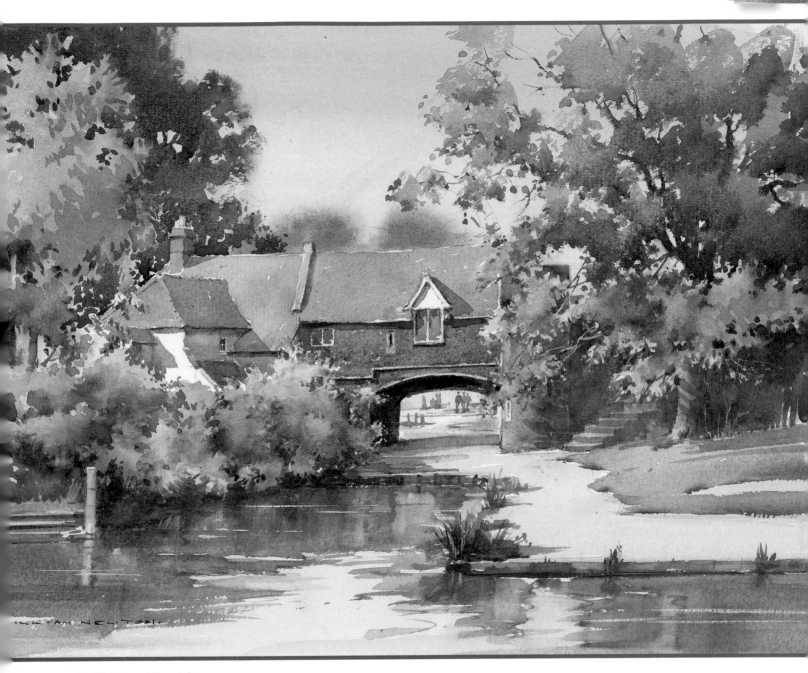

Pull's Ferry, Norwich

*I have used some licence in this picture. This view of the building is
actually mostly obscured by the large tree on the right, so I have pruned it
somewhat! The focal point is the dark arch against the bright background
– the point of greatest contrast in the painting. Note that the focal point is a
little off-centre.*

Drawing

The importance of drawing

Although this book is primarily about watercolour painting, we must try to get our drawing as correct as possible. Drawing and sketching can, of course, be ends in themselves and a great enjoyment. Indeed, drawing and painting are not separate issues but part of the same process. If you are using a fine-tipped brush, you are drawing, conversely if you are shading with a soft pencil, you could be said to be painting, so the two practices overlap. Our paintings will take on a more convincing appearance if we have practised our drawing. Draw, draw, draw!

Perspective in drawing

If you like to include buildings and architecture in your compositions, then it is worth the trouble to develop in your drawing a sense of perspective. There are two kinds of perspective to deal with: linear perspective, which concerns drawing and observations of lines, shapes and how they are affected by distance; and aerial perspective, which concerns the lessening of tones and colour as they recede into the distance.

Linear perspective

Three-point perspective

Horizontal lines, such as the courses of brickwork in a wall or the ridge on the top of a roof, appear to slope downwards as they recede into the distance when they are above eye level, while those below eye level seem to climb upward. The lines that are at eye level are dead level.

 In addition to the vanishing points on either side of the building, there is also a convergence of lines skyward. This is because, from ground level, the lower line of the gutter seems longer than the line on the ridge of the roof, because the bottom is closer to us than the top. The three points where the lines converge – to the left, the right, and above – lead to the term 'three-point perspective'.

This distant house uses the same lines to the vanishing point as the foreground buildings. Note how the angles on the lines are much smaller, making the building appear flatter.

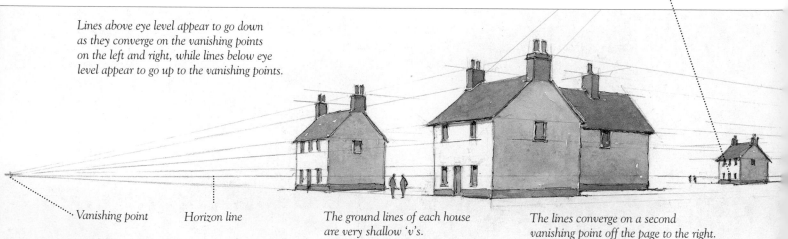

Lines above eye level appear to go down as they converge on the vanishing points on the left and right, while lines below eye level appear to go up to the vanishing points.

Vanishing point *Horizon line* *The ground lines of each house are very shallow 'v's.* *The lines converge on a second vanishing point off the page to the right.*

Point of view

How you draw a building or, for that matter, how you draw anything, depends upon your viewing point. You have to look carefully at each line and ask yourself, where should it be placed? Is it going up or is it running down? Is it leaning left or is it leaning right?

This also depends on the kind of landscape you are drawing. In a hilly area you may find the need to place your horizon line very high with very little sky since you may be looking down into valleys, whereas working in a flat landscape means your horizon line may be very low and it will become a 'sky' picture.

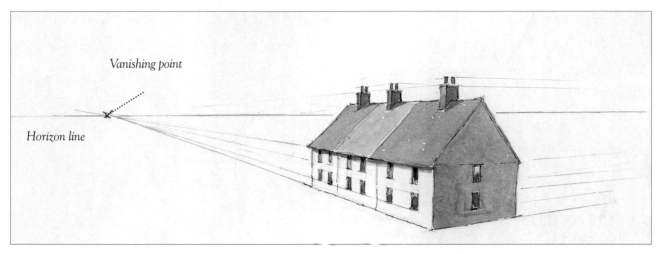

This example, like the one opposite, is on level ground. However, because we are viewing the buildings from a higher vantage point, the ground lines of each house are deeper 'v's than in the previous example. The horizon line is relatively higher, passing through the roofs of the terrace rather than being at eye level.

The two examples below are of the same street, which is set on a steep hill. The left-hand sketch shows the street from the bottom of the hill, and the right-hand sketch shows it from the top.

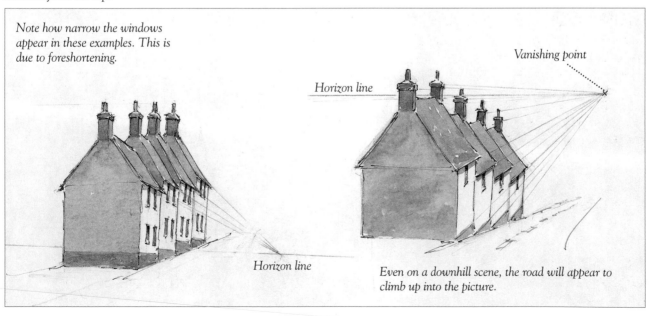

Note how narrow the windows appear in these examples. This is due to foreshortening.

Even on a downhill scene, the road will appear to climb up into the picture.

Foreshortening

When viewing buildings and other objects from increasingly acute angles, certain parts will gradually become thinner and eventually disappear behind other areas. This effect is known as foreshortening.

I have shaded areas of the building in the sketch to the right. These areas will vary in width depending on the viewpoint, as illustrated below. Note how the windows become simple vertical pencil lines as the angle of view becomes more oblique, and also the way in which horizontals such as the gutter-lines on the building become steeper. The sketch below right shows the house square-on.

The original sketch.

Of course, any of the viewed angles may work well enough in a painting but from whatever angle you are looking, it is worth drawing it accurately. There is a tendency in students to widen the foreshortened planes.

In considering the scene before you, whether in the open air, in a reference drawing from your sketchbook or even a photograph, you should take careful note of the foreshortening effect that viewing a building (or for that matter, anything) has on the shapes of the various elements within.

The dotted lines show how the visible area of the shaded wall gradually narrows or broadens as the viewpoint changes.

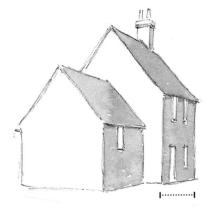
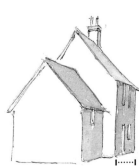

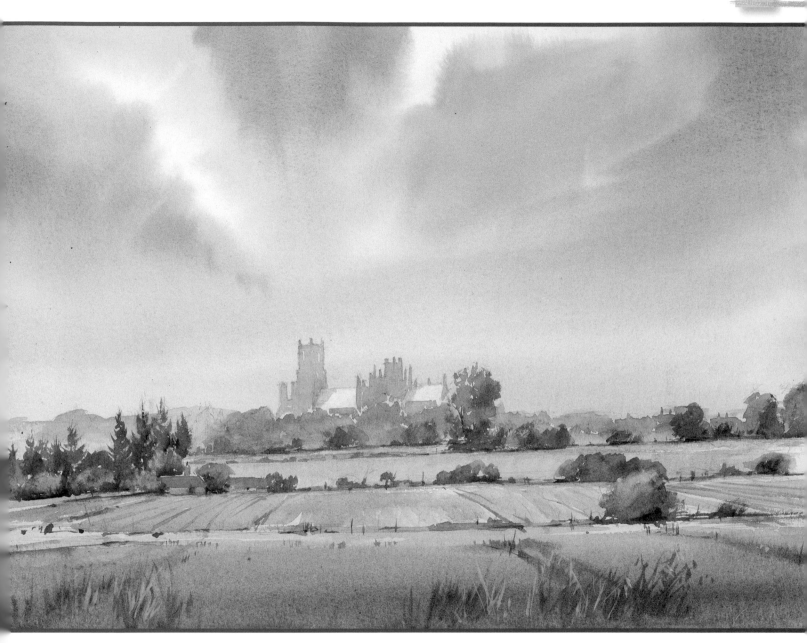

Aerial perspective

Sometimes referred to as atmospheric perspective, aerial perspective is the weakening of tones and colours as they recede into the distance – both light and dark tones become duller to a midtone. Similarly, colours become less strident and start to look more grey-blue. This phenomenon, like linear perspective, could be said to be an illusion. The colours and tones of those distant roofs and trees are not really weaker but just seem so with recession and distance.

We can exploit this impression to improve the three-dimensional qualities of our paintings by exaggerating the 'blueness' and the fading of tones in the distance.

The Ship of the Fen

This picture was painted to illustrate the principle of aerial perspective. Ely Cathedral is ideal for the purpose since it is visible from a great distance. The building itself has been painted using dilute cobalt blue laid on to the sky washes with the light-coloured roofs lifted out, taking care with tone in order to keep it distant. Working from the Cathedral back to the foreground, the tonal values of the fields, trees and hedgerows are gradually darkened.

Drawing what you see

While it is important to understand the principles of perspective, it is also important to learn to draw what we see rather than what we know.

When you have a complex or confusing subject, you should look at shapes as an alternative to relying purely on perspective. Compare small areas such as the windows or fronts of particular buildings. Once you have identified the first of these small areas, look at how it relates to the other shapes around it and gradually build up the picture. You are aiming to identify simple spaces and shapes in order to help achieve the correct proportions.

Gold Hill, Shaftesbury

This famous scene on a steep hill, with houses almost seeming to tumble down the gradient, makes for an unusual composition. Notice how the horizon has to be placed very high with almost no sky when looking at a downhill view.

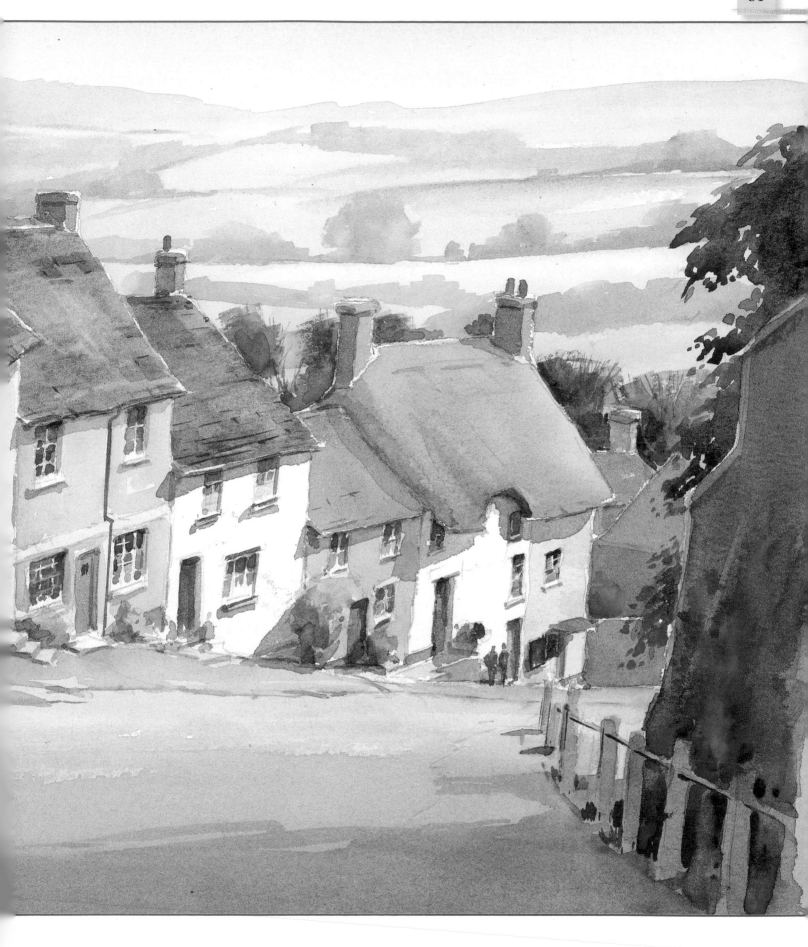

Shapes

Buildings

Perspective is always important but in compositions like the one to the right, plotting multiple vanishing points can be more confusing than helpful. Drawing complex street scenes like these is about identifying irregular shapes and how they fit together, whilst closely observing the effects of foreshortening.

Accuracy will come by comparing these shapes and trying to draw them in proportion to each other.

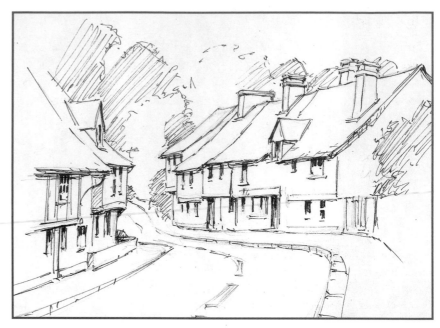

Saffron Walden

In a scene like this, I love the way the man-made parts – the old buildings themselves – interact with nature's parts, the trees. The buildings themselves look as though they were never designed but have just evolved, brick by brick, tile by tile and window by window. Notice how the roofs sag and how some verticals are not quite upright.

Faces

Portrait painting, more than any other subject, requires accuracy of placement. The features must be correctly placed. Good likenesses that not only look like the sitter but bring out the character of the person, can be elusive. The only answer is practice, practice and more practice.

When you look at a face straight on, the eyes of an average adult are about half way up the oval of the head. The bottom of the nose about a quarter of the way up and the shadow under the bottom lip about an eighth of

the way up (see below left). Ask yourself if your subject conforms to this formula. If not, why not? Is their nose longer? Is their mouth higher or lower? In asking yourself these questions, you are surely beginning to sharpen your powers of observation.

You will notice on the child example (below right), all the features are closed up and lower still on the oval of the head.

When drawing the head from different angles, take note of how the features change when the head is rotated, up or down or from side to side.

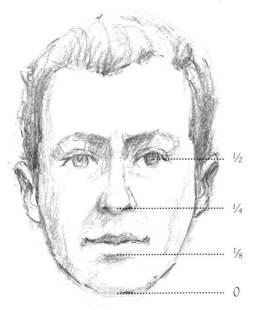

These full face diagrams are intended only as a useful yardstick. Comparing the proportions of the faces of people you see with these will help you identify if and how they conform to these classic perfect proportions.

½

¼

⅛

0

Upside-down drawing

Turning your reference image upside-down is intended to make you see shapes without seeing them as recognisable objects or features. This works for any subject, but is particularly useful for drawing faces. The shape is built up by visually measuring and comparing each line you draw with the last one, rather than by identifying features like eyes and noses then drawing them.

When looking at the finished painting (below), the image is instantly recognisable as a face. When turned upside down (see right), you are distanced from the instant recognition, and will find it easier to see shapes and spaces that will, in turn, make it easier to draw in proportion.

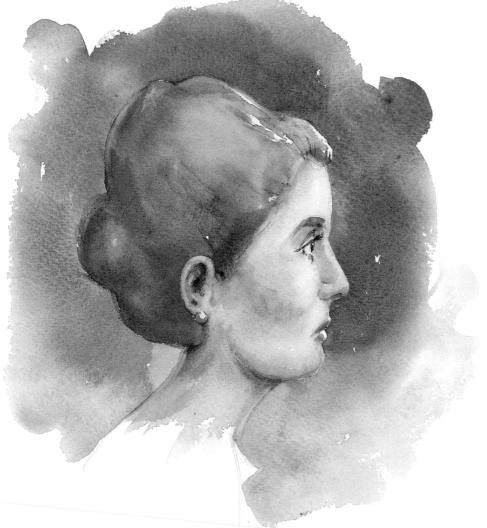

Architectural shapes

Since I love drawing, my landscapes almost always contain some prominent architecture. Old farmhouses, barns, churches, boats and boat sheds; all are a satisfying challenge.

More complex architecture in townscapes and harbour scenes (such as on pages 66–67), demand careful planning. As I mentioned earlier on page 60, I usually begin to draw by looking very carefully at the overall subject and selecting a starting point. This is normally one vertical line somewhere near the centre of the paper.

With complicated compositions, it is best to work on a piece of watercolour paper that is a little larger than the finished painting will require. The picture can then be cropped to bring about a good compositional balance by adjusting the position of the aperture of the mount (called matting in the US) for an optimum result.

Some features that are particularly complex are dormer windows and round forms. These are explained below.

Dormer windows

Dormer windows can be tricky to draw properly. Look carefully at the lines in the sketch, they are mostly self-explanatory.

The line marked 'x' can be difficult to determine since it will vary in angle from different viewpoints. Ask yourself how any of the lines you are drawing compare with the vertical or the horizontal.

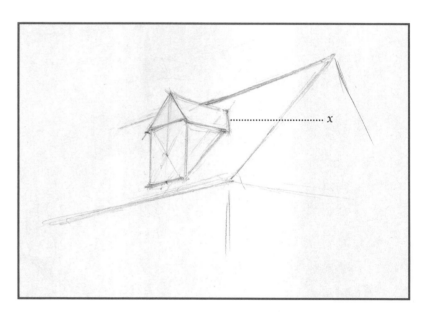

Round forms

However steep and abrupt the angles of perspective on a chimney stack might be, the ellipses of the chimney pots themselves are always level and symmetrical, although the shape of the ellipse itself will vary in up and down deflection depending on the viewing distance. This would apply to anything of cylindrical form: cups, pots in a still life, or round buildings in architecture such as oasthouses, lighthouses or brick-built windmills.

As far as ellipses in architecture are concerned, note that on a round building made of bricks the course of bricks at eye level will be a straight line, those above eye level will curve upwards and those below eye level will curve downwards.

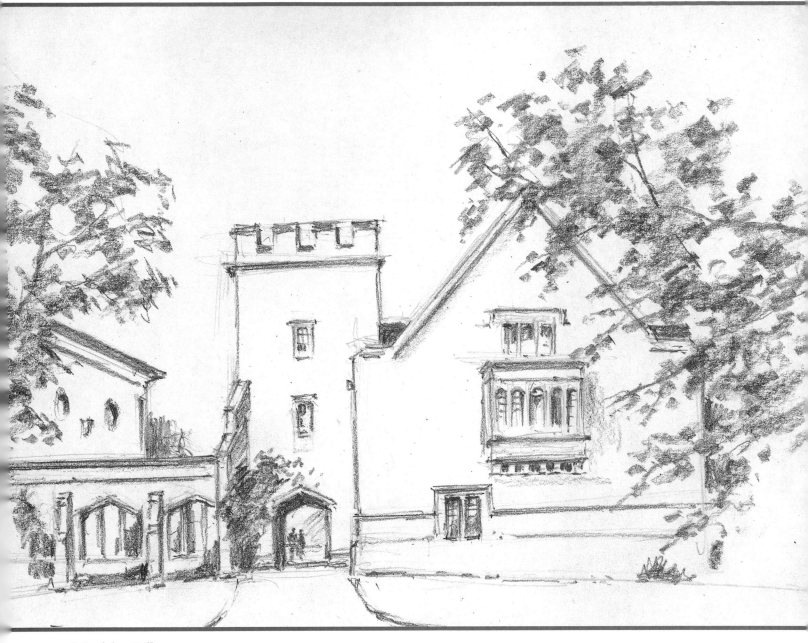

Magdalen College

This is a corner of Magdalen College of Oxford University. Apart from being a pleasurable challenge, buildings like these – made of a lovely warm-coloured stone – offer good opportunities for depicting shadow and, consequently, the light. Care must be taken to draw the angles and proportions of the architecture. The small figures under the arch help to give a sense of scale and animation.

Step-by-step projects

In the following pages we put into practice some of what we have learned earlier in the book. I have included a variety of subjects to challenge and develop your skills, beginning with a landscape including trees – the depiction of which employs a mixture of techniques where dry brush, wet into wet and wet on dry are all used together.

There is a low tide marine picture with free fluid washes plus the use of the rigger brush for its named purpose. In the *Village Street* and *Magdalen College* projects, the aim is to simplify what are complex architectural subjects while still creating atmospheric recession and using a certain amount of free brush work.

There is an unusual still life study of an old ship's cannon in which wet into wet techniques are used to paint the cylindrical barrel and, finally, a portrait study of a wonderful character, John, in which more wet into wet techniques and graduations are used with hard and soft edges.

Polperro, Cornwall

This is a large 63.5 x 43cm (25 x 17in) painting that almost fills a whole sheet of Saunders Waterford 640gsm (300lb) rough paper. It is a studio piece with some variations produced from a smaller work painted from the opposite harbour wall on an earlier visit. This beautiful coastal village has been the inspiration for many, many artists for centuries. I have also painted scenes from the harbour floor at low tide.

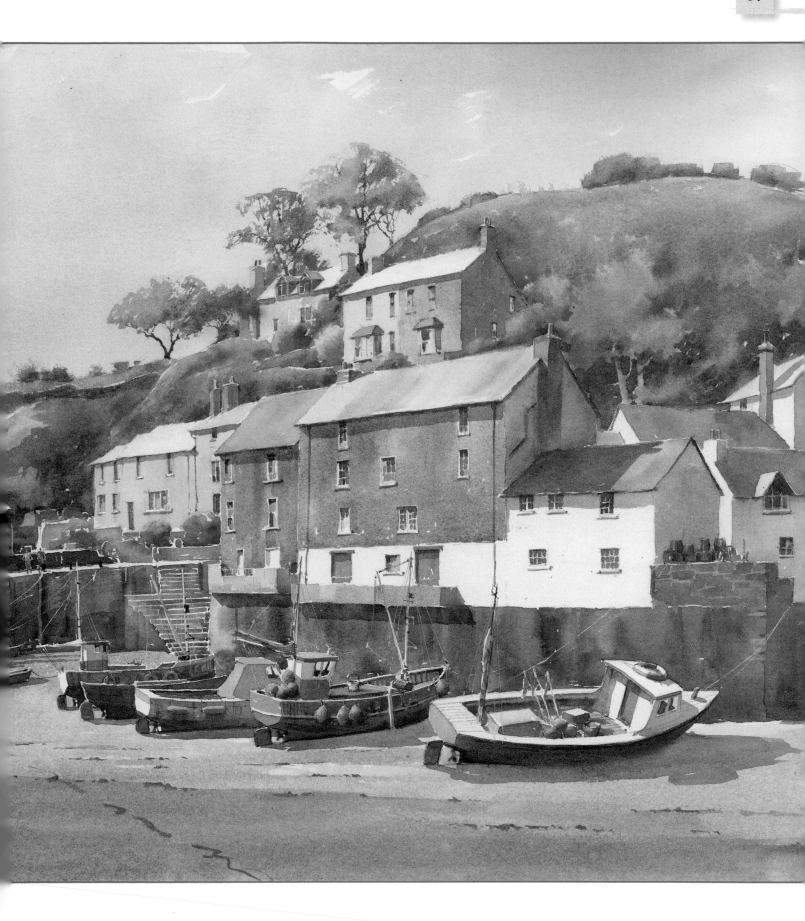

Farm Track

This landscape project shows that we can paint a landscape with a good variety of tones and colours, particularly in the trees and foliage, with only a few paints.

You will need

Waterford rough surface 300gsm (140lb) paper

Brushes: 37mm (1½in) flat synthetic, 25mm (1in) flat synthetic, size 6 round, size 12 round, size 2 rigger, size 4 round

Colours: raw sienna, warm orange, French ultramarine, cobalt blue, lemon yellow, light red, cadmium red

Picture tape

2B pencil

Putty eraser

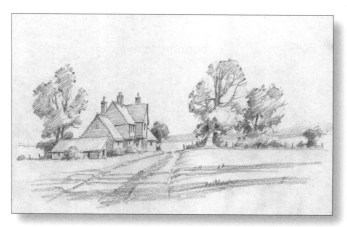

The tonal sketch for this project.

1 Use a 2B pencil to reproduce the basic lines of the sketch on Waterford rough surface 300gsm (140lb) paper, then secure it to the board with some picture tape at the corners only. Use a 37mm (1½in) flat brush to wet the sky with clean water. Work right down to the horizon and over the trees, but change to the size 6 round to work around the building.

2 Pick up very dilute raw sienna with a 25mm (1in) flat brush and lay in a faint wash around the horizon, and up towards the top of the sky. Rinse your brush. While the raw sienna is still wet, pick up warm orange and lay the colour in areas above and around the raw sienna to blend them together.

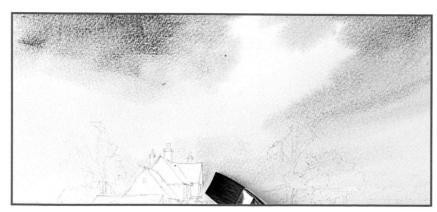

3 Working quickly, pick up French ultramarine and a little warm orange on the 37mm (1½in) brush. Paint the top of the sky, working into and around the colours in the middle of the sky to suggest clouds. Change to a clean 25mm (1in) brush and use dilute cobalt blue to work a faint band across the horizon, using the edge of the brush to work into the hard edge of the building.

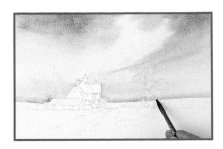

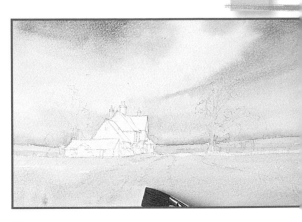

4 Pick up dilute cobalt blue with the size 12 round brush and run it along the horizon, allowing the colour to bleed slightly into the horizon. Allow the painting to dry.

5 Use the size 12 round to lay in slightly diluted raw sienna over the distant fields in the background, working wet on dry. Paint the trunk of the right-hand tree with the same colour and brush. Before the raw sienna dries completely, pick up lemon yellow on the size 12 and develop the closest edge of the fields.

6 Wash over the foreground with raw sienna, applying the paint with broad horizontal strokes and the size 25mm (1in) brush. Make the colour slightly stronger towards the front of the painting (the very bottom of the picture). Allow the painting to dry.

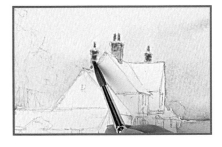

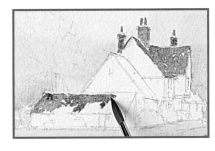

7 Use a size 6 brush to paint the chimney pots with a terracotta mix of cadmium red and raw sienna, then add a little French ultramarine and paint the chimney stacks. Leave a small gap of white paper showing between the parts for a highlight.

8 Use the terracotta mix with the size 6 to begin to paint the rooftop of the main house, leaving a few gaps of clean paper for interest. Add light red to the mix and paint the roof of the outbuilding.

9 Paint a few other terracotta details, leaving them broken where the area is partially obscured by foliage. Combine the terracotta mix with raw sienna and paint the brickwork of the house.

10 Still using the size 6 round, mix burnt umber with French ultramarine and paint the weatherboarding of the outbuilding. Leave some space for foliage on the side. Paint the dark beams on the main house with the same mix and brush.

11 Develop the foliage around the house using lemon yellow, adding touches of shading to the underside of the foliage with French ultramarine. Vary the hues with raw sienna to ensure a natural variation.

12 Paint the final roof with dilute cobalt blue and a clean size 6 brush to complete the base layer of the farm building.

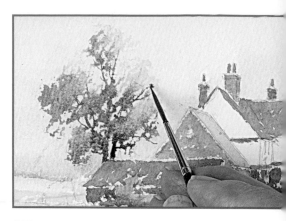

13 Begin to paint the light parts of the tree next to the house using the side of the size 6 brush with lemon yellow and raw sienna. Use the dry brush technique to suggest the texture of the foliage on the surface of the paper.

14 Working quickly, add shading with French ultramarine and raw sienna, still using the side of the brush. Ensure you leave some gaps in the tree, and apply this colour fairly sparingly below and to the left of large light areas.

15 While the paint is still wet, change to a size 2 rigger and pick out the visible areas of the trunk and main branches with a dark mix of French ultramarine and burnt sienna. Allow the colour to bleed into the wet paint of the foliage.

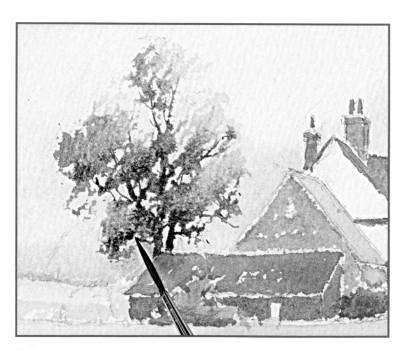

16 As the paint begins to dry, the tonal value will change and the colour will be lighter. If you wish, add a little of the dark mix to the darkest areas of the wet foliage.

17 Surround the roof with a dark grey-green mix of French ultramarine and raw sienna. This represents shrubs surrounding the main tree and allows you to add counterchange to the roof of the building.

18 Do the same on the lower right-hand side of the building. Since this small tree is in the light, add a little lemon yellow to the right-hand side, working wet into wet.

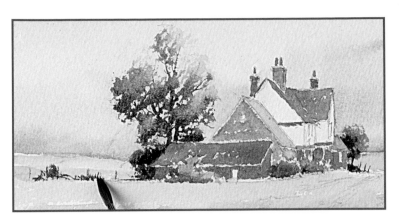

19 Suggest small fenceposts and grass and bushes in front of the house with the dark mix of French ultramarine and burnt sienna.

20 Begin to paint the group of trees on the right-hand side of the painting as in steps 13–15. Make the largest tree slightly warmer to draw the eye by using autumnal colours such as burnt sienna added wet into wet after the light parts but before the dark parts.

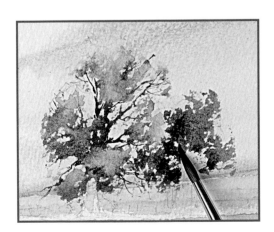

21 Use cobalt blue and raw sienna to make a dull grey-green and paint the smaller tree on the right-hand side. Because this tree is behind the larger one, tease the colour in around the right-hand side. Add more cobalt blue for the darker shaded areas.

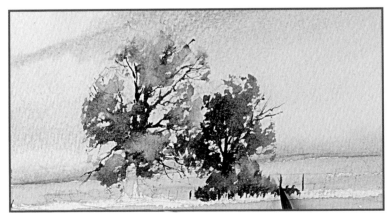

22 Use lemon yellow and raw sienna to paint the lighter parts of the tree in the light. While the paint is still wet, develop the overgrown fence line with the suggestion of scrubby grasses and fenceposts. Use the size 6 round brush with the dark mix of French ultramarine and burnt sienna to add these details.

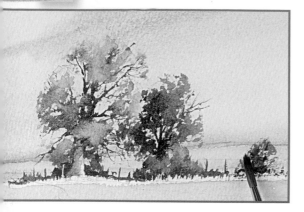

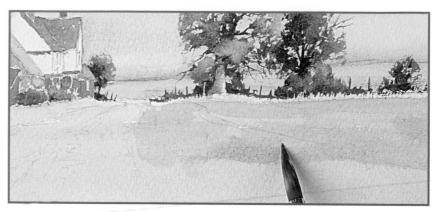

23 Using the size 6 and dark mix (French ultramarine and burnt sienna), work the fence and bushes to the right-hand edge of the painting. Vary the colour with cobalt blue and raw sienna.

24 Allow the painting to dry completely, then change to a size 12 brush. Use lemon yellow as a glaze to begin to develop the foreground fields, leaving a few gaps of the underlying colour to show through.

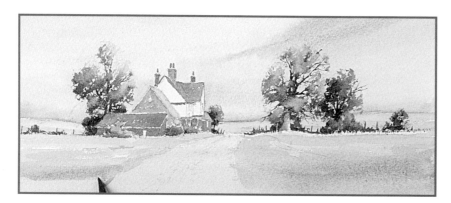

25 As you work towards the front of the painting, add a little French ultramarine.

26 Still using the size 12 round, develop the grass in the centre of the track in the same way, then use the tip of the brush to suggest broken areas with French ultramarine.

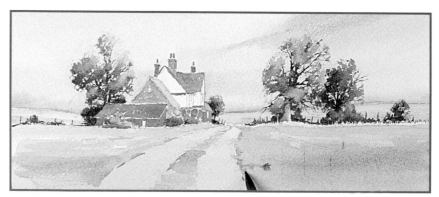

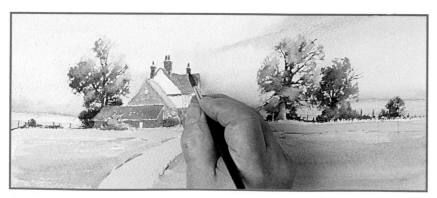

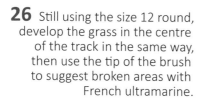

27 Allow the painting to dry completely, then use a size 6 round brush to lay in glazes of dilute French ultramarine to the left-hand sides of the chimney pots. Dilute the colour further for the rooftop facing you.

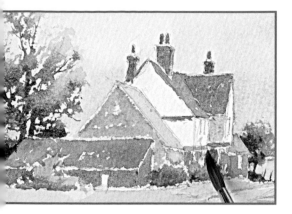

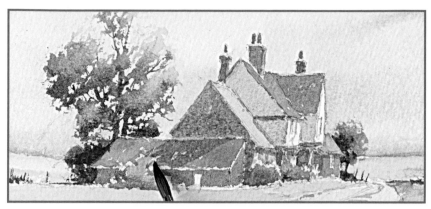

28 Work down to the ground with dilute French ultramarine, using the tip of the brush to pick out the shadows cast by guttering, in window recesses and other details.

29 Use the same colour and brush to glaze over the other areas of the house in shadow. The roof of the main building will cast a triangular shadow over the roof of the outbuilding as shown.

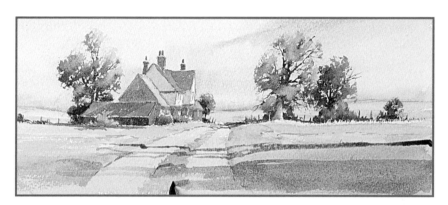

30 Change to a size 12 round and paint shadows on the foreground cast by a tree just out of frame using dilute French ultramarine. Follow the shape of the ground, dipping into the track.

31 Use the tip of the brush to add a few tiny touches of the same colour rising from the shadows in order to suggest the texture of the grass. Ensure these marks are tiny.

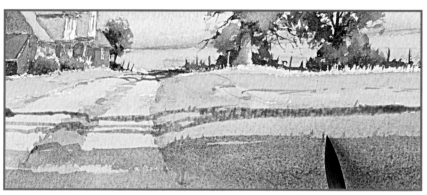

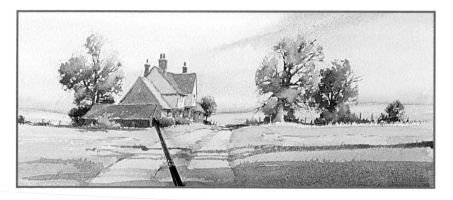

32 Change to a size 4 and add some small details to the gutters, tops of the windows and eaves of the building to tighten the shadows a little. Once dry, use the putty eraser to remove any pencil lines to finish the painting.

Overleaf:
The finished painting.

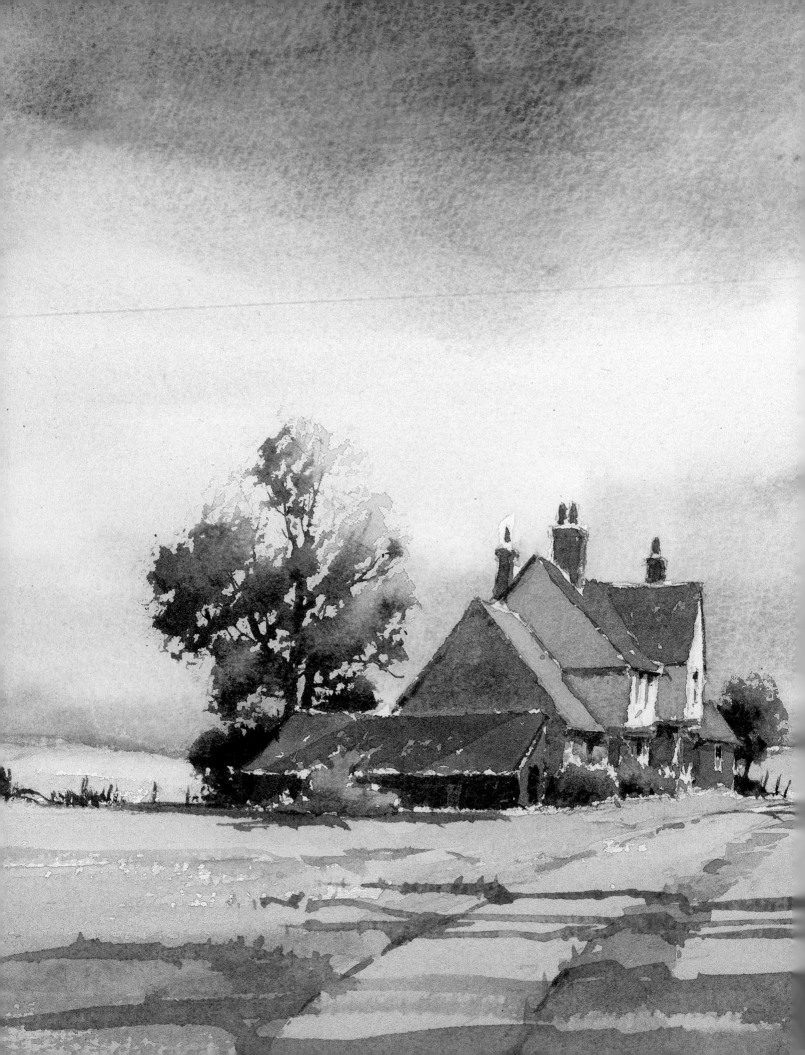

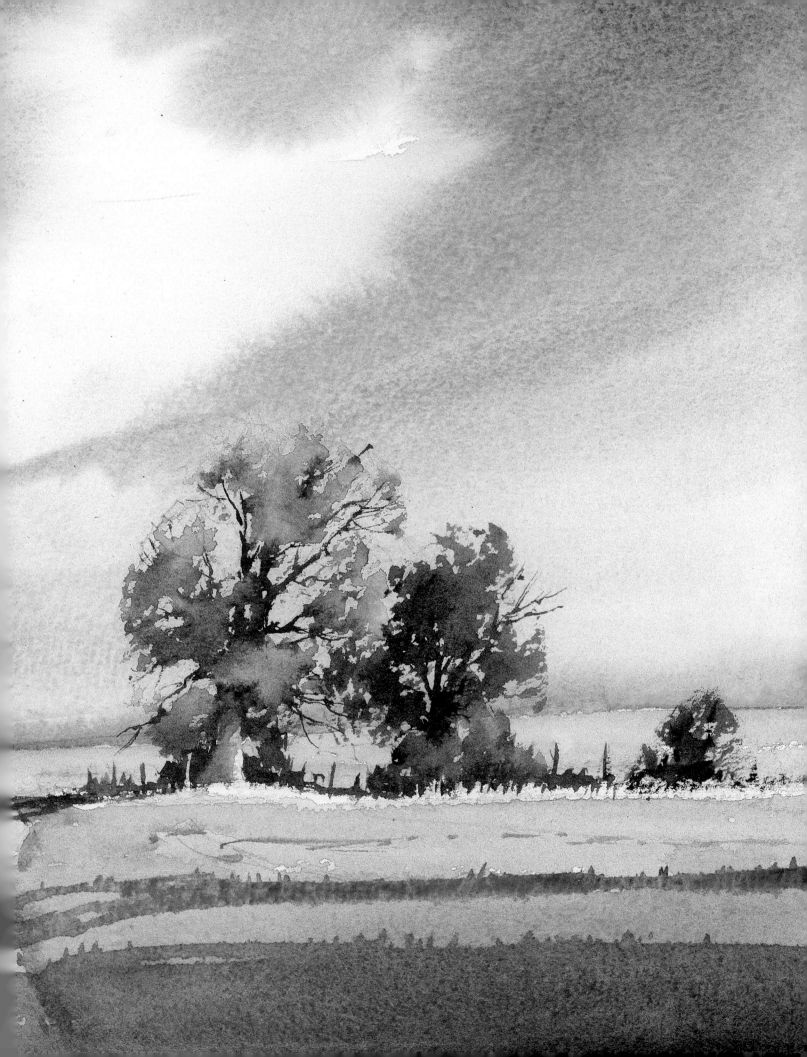

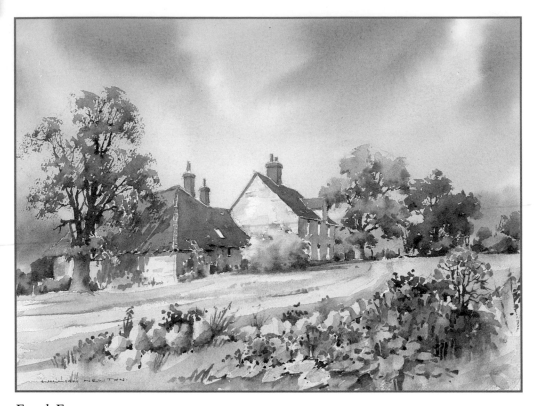

French Farm

These old farm buildings were rather derelict and uninhabited when I saw them, so I have done a little 'rebuilding and re-arrangement'!

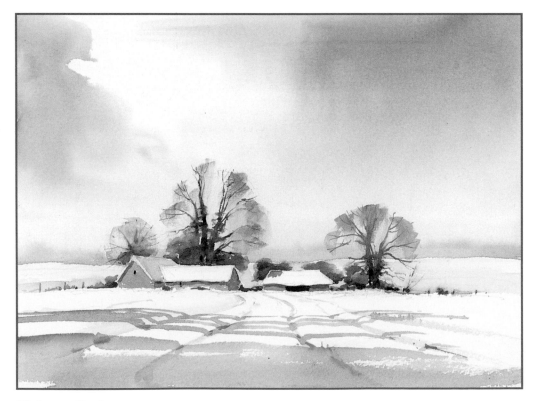

Christmas Card

The subject of this snow scene is a complete invention and was a demonstration painting for a watercolour workshop.

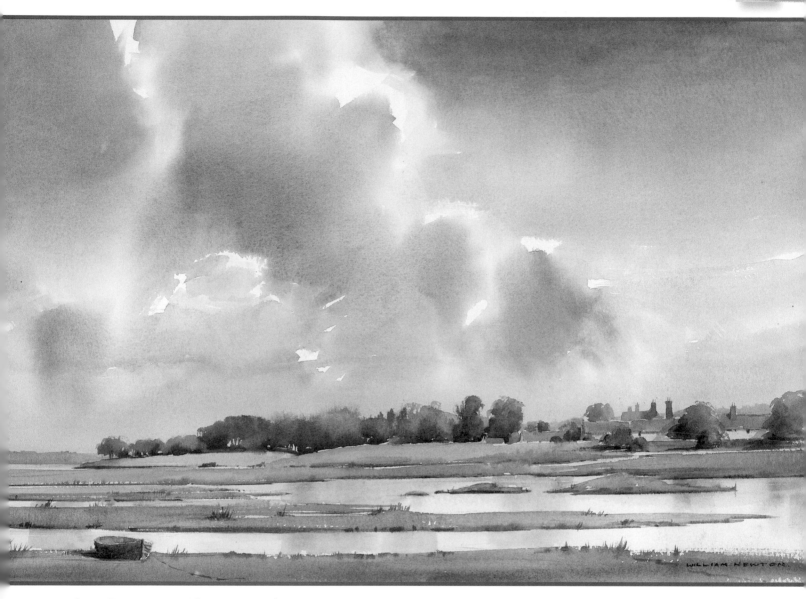

Storm Brewing over Blancaster Staithe

This is a large studio painting that was worked from a smaller demonstration sketch produced on location whilst tutoring a painting holiday in Norfolk.

Barges on the Mud

The tonal sketch (below right) depicts a scene on a river, but it has been somewhat simplified for this exercise. The painting is executed with initial washes of colour freely applied to set the atmosphere on this peaceful tide-out morning scene. Darker washes of colour model the shapes of the boats and represent shadows to give a strong sense of light, then final details are suggested with a size 6 sable brush and a size 2 sable rigger.

With this painting I wanted to engender the sleepy atmosphere of the river at low tide, by keeping the overall scene simplified with soft washes without losing the majesty of the sailing barges.

You will need

Waterford rough surface 300gsm (140lb) paper

Brushes: 37mm (1½in) flat synthetic, 25mm (1in) flat synthetic, size 12 round, size 6 round, 12mm (½in) flat synthetic

Colours: raw sienna, warm orange, Prussian blue, French ultramarine, cobalt blue, lemon yellow, cadmium red burnt umber, brown madder, light red

Picture tape

2B pencil

Ruler

Putty eraser

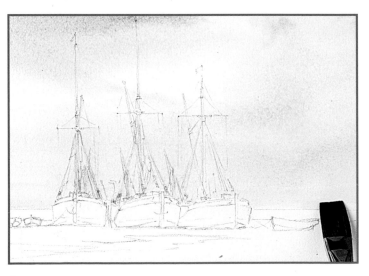

The tonal sketch for this project.

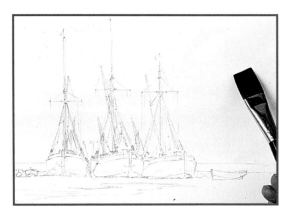

1 Use a 2B pencil to reproduce the basic lines of the sketch on Waterford rough surface 140lb paper, and secure it to the board with some picture tape at the corners. Wet the sky with clean water and a 37mm (1½in) flat brush. Work over the masts and rigging right down to the tops of the boats and the horizon, using the edge of the brush to ensure clean lines here. Change to the 25mm (1in) flat brush with loose strokes to apply dilute raw sienna from the horizon up towards the middle of the sky.

2 Rinse your 25mm (1in) brush. While the raw sienna is still wet, pick up warm orange and develop the areas above and around the raw sienna to create a blended effect. Working quickly, prepare a mix of Prussian blue and French ultramarine. Lay in a faint wash with the 25mm (1in) flat towards the top of the sky for a graduated effect. Add a dilute stroke of the blue mix above the top of the boats.

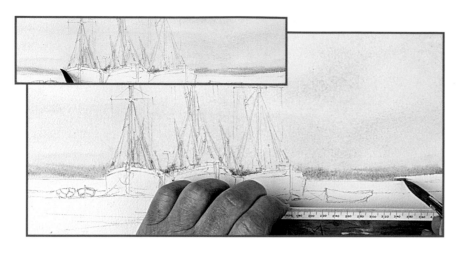

3 Develop the band across the whole horizon. While the paint is still a little wet, use a size 12 round to draw a darker land area across the horizon using a mix of cobalt blue and raw sienna (see inset). Mix lemon yellow with cobalt blue and paint the closest part of the land. Ensure that the waterline is dead straight.

4 Using a ruler to help ensure your lines are straight, use the tip of the size 12 brush to apply an extremely dilute mix of Prussian blue and French ultramarine over the waterline as shown.

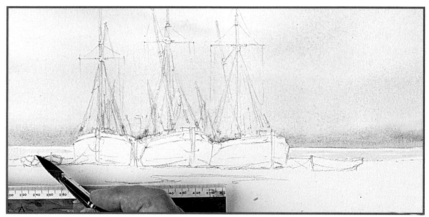

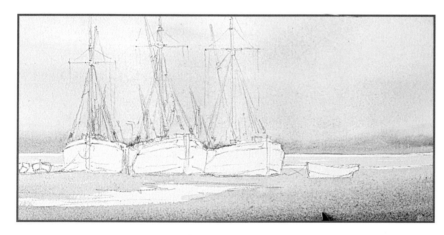

5 Clean the size 12 round and lay in a dilute wash of raw sienna across the whole beach in the foreground. Avoid the puddle in the centre, leaving it as clean paper. Vary the beach with touches of lemon yellow and tiny subtle touches of French ultramarine and burnt umber, adding the colour wet into wet.

6 Paint the puddle in the centre of the beach with the dilute mix of Prussian blue and French ultramarine to represent the sky reflecting in the water, then tease in some dark areas on the edge of the puddle with a stiff (fairly undiluted) mix of French ultramarine and raw sienna.

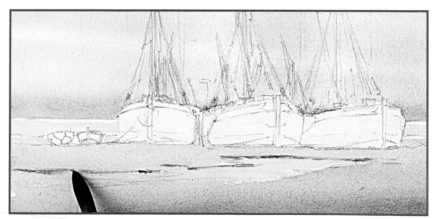

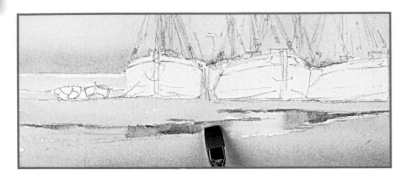

7 Change to a 12mm (½in) flat brush. Dampen it and pick up some of the stiff mix of French ultramarine and raw sienna. Use this to paint the reflections of the left- and right-hand boats in the puddle. The light source is on the left of the picture, so dilute the left-hand parts of the reflections to make them lighter. The central boat will be white, so the reflection will be light-toned. Paint its reflection using very dilute mix of the same colours.

8 Change to a size 6 round brush and use a ruler to help you draw a fine line of a very dilute mix of French ultramarine and burnt sienna across the waterline on the far side of the river.

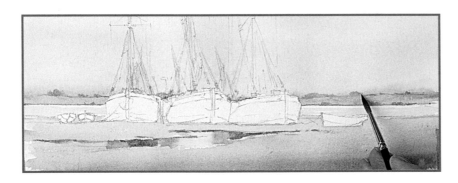

9 Tease the wet colour up into the land to represent hedgerows and trees, then make a dilute greenish grey mix from the remnants of dried mixes on your palette (lemon yellow and French ultramarine make a good basis for a fresh mix). Use the brush tip to suggest background detail.

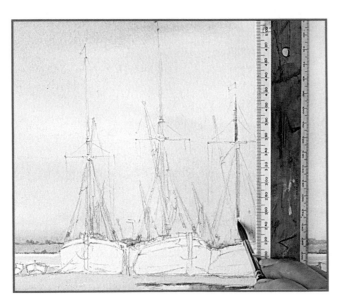

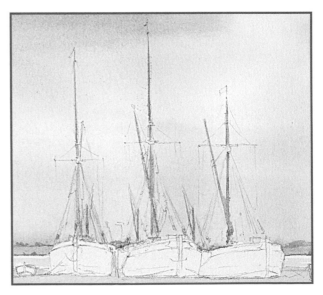

10 Once the painting is completely dry, hold a ruler parallel to the mast of the right-hand boat. Load a size 6 round with burnt sienna. Rest your finger and the ferrule of the brush on the ruler and draw the brush down from the top to paint the mast. Use very little pressure at the top to ensure the line is narrow, and more towards the bottom as the mast thickens. Break the line occasionally where rigging crosses the mast.

11 Paint the other masts on the right-hand boat in the same way. While wet, add a touch of French ultramarine to areas of shadow. Still using the size 6 round, paint the masts on the other boats. To create striking contrast, make the tops of the masts dark against the sky. The bases of the masts can be lighter, as they will have light reflected back on to them from the deck of the boat.

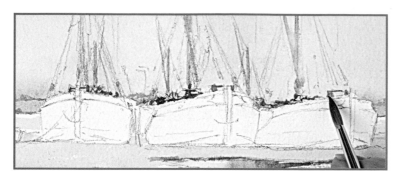

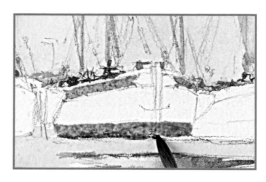

12 Use various mixes of French ultramarine and burnt sienna to add details such as the windlass, the wheel and other dark areas on the deck of the central boat with the tip of the size 6 brush, then paint details on the other two boats in the same way.

13 With dilute Prussian blue, paint the gunwale (top of the hull) of the central boat with the size 6 round. Paint the hull by the waterline with light red, then draw a little French ultramarine across the very bottom, allowing the colour to bleed upwards into the hull.

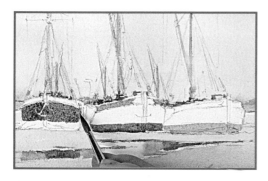

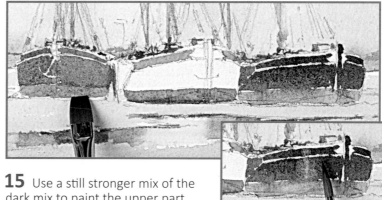

14 Still using the size 6 round, create a dilute dark mix of French ultramarine and burnt sienna and paint the lower part of the right-hand boat's hull. Use a stronger mix for the hull of the left-hand boat, carefully avoiding the anchor.

15 Use a still stronger mix of the dark mix to paint the upper part of the right-hand boat's hull. Aim to leave some lines of clean paper between sections to represent highlights. Paint the bottom of the left-hand boat's hull with light red and the 12mm (½in) flat. While the paint is still wet, use a clean size 6 brush to lift out a highlight on the right-hand boat (see inset).

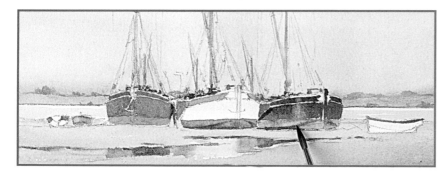

16 Paint the smaller rowing boats to the sides using Prussian blue and light red as shown. Still using the size 6 brush with the dark mix of French ultramarine and burnt sienna, continue modelling the boats.

17 Mix raw sienna and brown madder and paint the sails with the size 6 round. Use the ruler to help you when working behind the mast. Add some subtle shadows with dilute French ultramarine.

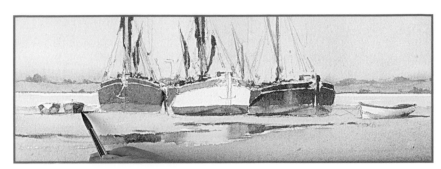

18 Paint the bobs (small pennants) on the top of each main mast using whatever bright colours you like (from left to right in my example: lemon yellow, cadmium red, Prussian blue).

19 Draw dilute French ultramarine along the base of the rowing boat on the right-hand side, then rinse your brush and draw the colour up to suggest the shape of the boat. Working wet into wet, pick up a touch of burnt sienna and feed the colour into the right-hand side. Draw the colour out to the right to suggest a soft transition into darker shadow, then draw the colour out on to the sand as cast shadow. Shade the rowing boats on the left-hand side in the same way.

20 Change to a size 2 rigger, add French ultramarine to burnt sienna for a dark mix and paint the crosstrees (the horizontal parts on the masts). Use the ruler to help your accuracy.

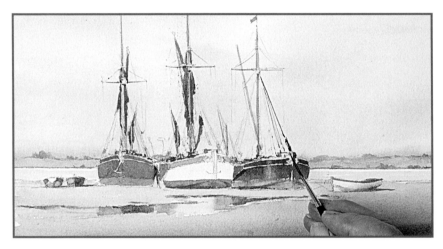

21 Using the same brush, mix and techniques, begin to paint the main parts of the rigging. Where the rigging meets the deck, add the suggestion of blocks, rungs or other details.

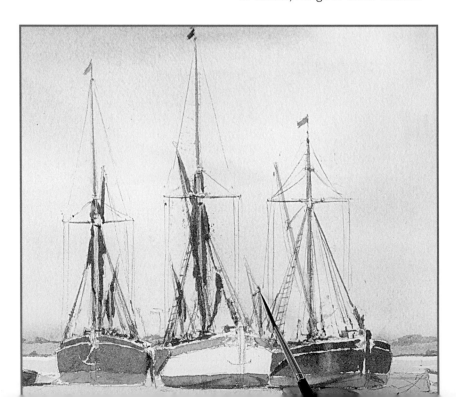

22 Paint the rigging across the rest of the picture in the same way. Where the rigging is slack or curved, do not use the ruler, but paint freehand. Be careful to ensure that the rigging is very fine – a broken or missing part of the line is better than a too-thick one.

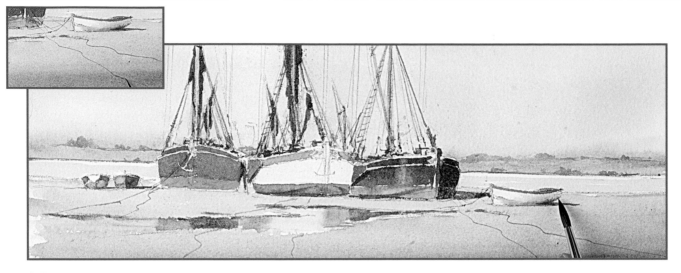

23 Use the same mix with the size 2 rigger to paint mooring ropes running from the boats to the shore. Use these to lead the eye into the picture and create a sense of perspective (see inset). Change to the size 6 round brush and use the dark mix to add a few dark touches to the right-hand sides and recesses of the sails. Glaze the shaded part of the hull of the right-hand boat and draw the colour out over the sand.

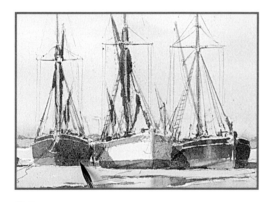

24 Using the same mix and brush, paint the shadows cast by the boats on one another. Glaze the right-hand sides of the hulls and draw the colour out, being careful to follow the shapes of the shadow carefully.

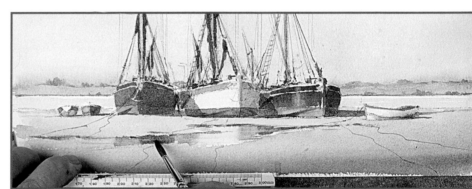

25 Link all of the boats by drawing a subtle line of the dilute dark mix under the hulls, following the places they sit on the sand, then clean the size 6 round brush and remove excess water. Use the ruler to draw the damp tip across the surface of the puddle as a highlight.

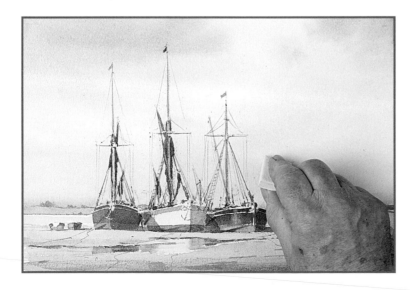

26 Add a few roughly horizontal details with the tip of the size 6 round and a very dilute mix of raw sienna, brown madder and French ultramarine. Finally, make any adjustments using the dark mix (French ultramarine and burnt sienna), such as painting the anchor on the central boat. Allow the painting to dry thoroughly, then use a putty eraser to remove the pencil lines to finish.

Overleaf:
The finished painting.

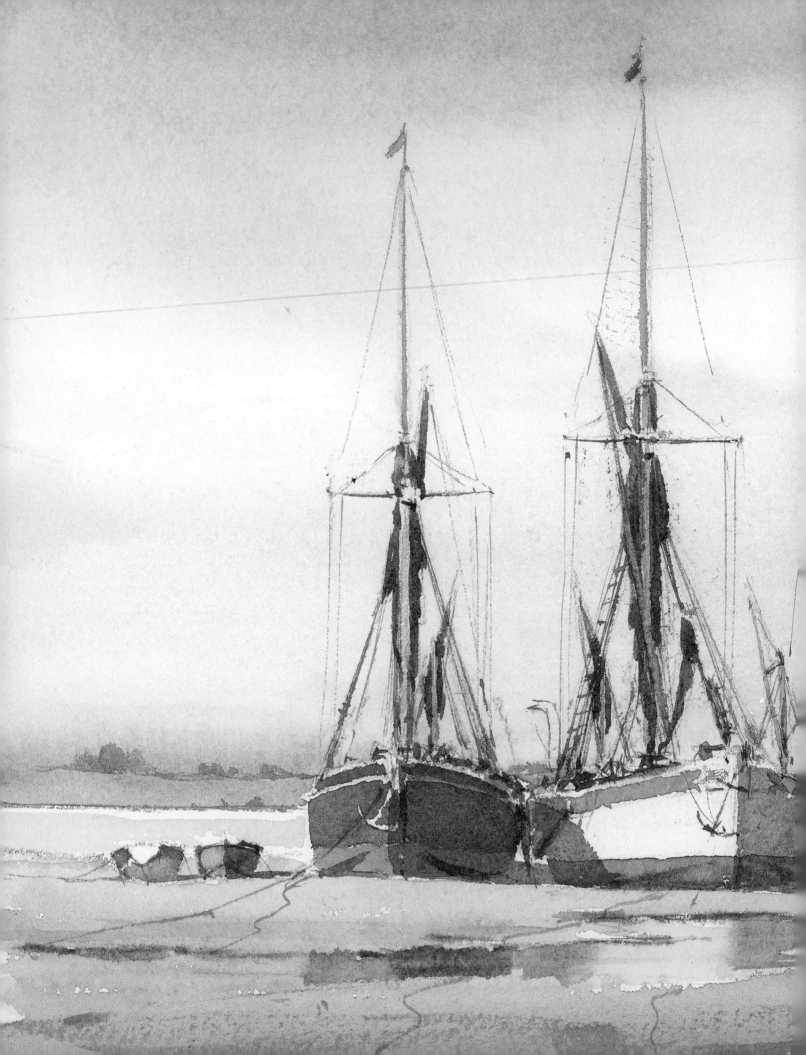

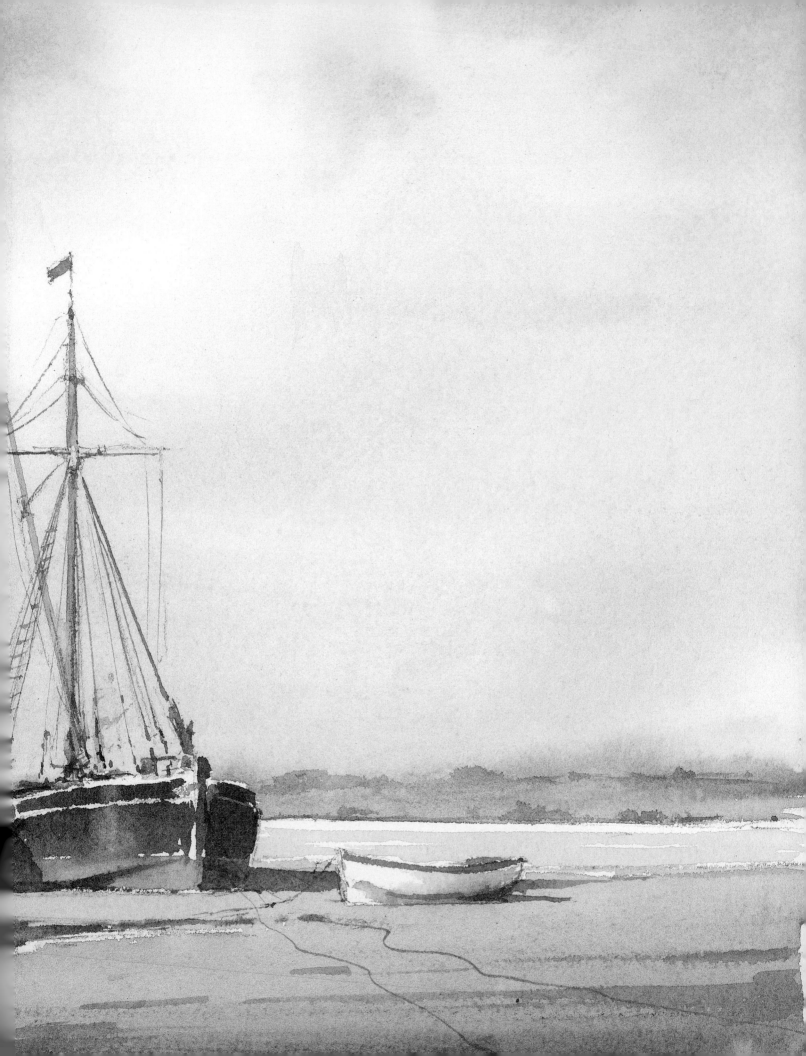

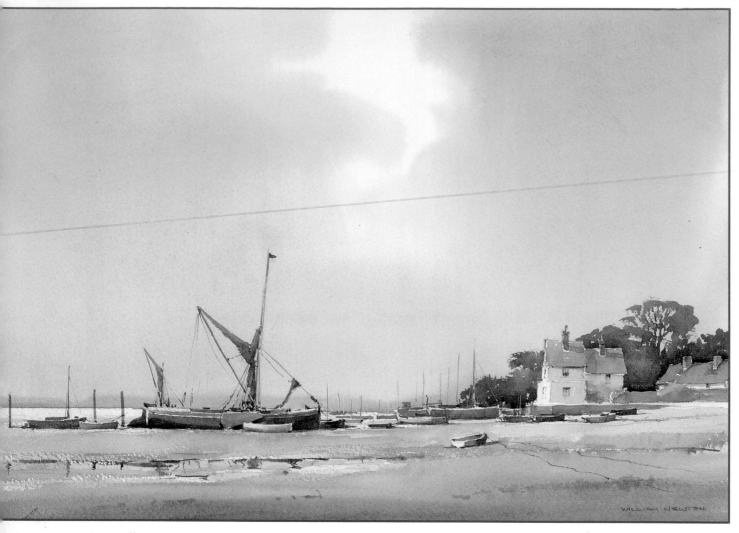

Pin Mill

This is a large painting, 56 x 38cm (22 x 15in), produced as a demonstration at an art society request. It was executed in approximately one and a half hours.

Pin Mill has been a popular artists' venue for decades and is full of boats, old and new. It is an interesting subject providing a measure of landscape with trees, architecture of the riverside pub, and of course, it has an underlying maritime atmosphere.

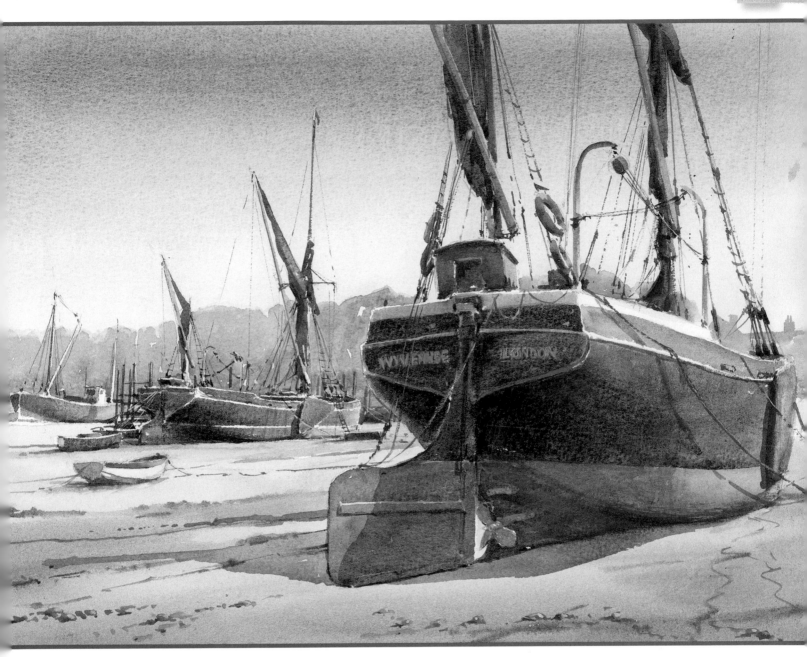

Low Water

Irrespective of the actual subject matter I like to impose on my paintings a strong sense of light. With the sun high at about midday, the shadows are not long but are quite dark under the shapely transoms of both sailing barges, allowing good modelling of the hulls. The strongest tones are reserved for the nearest boat.

This painting came about as a result of tutoring a four-day painting and sketching cruise aboard the nearest barge in the picture.

Village Street

In this demonstration I want to show that recession and a three-dimensional effect can be achieved even in a relatively short distance. Notice how the foliage is treated differently with distance: compare the nearer foliage with the trees in the background.

You will need

Waterford rough surface 300gsm (140lb) paper

Brushes: 37mm (1½in) flat synthetic, 25mm (1in) flat synthetic, size 12 round, 12mm (½in) flat synthetic, size 4 round, size 6 round

Colours: raw sienna, Prussian blue, French ultramarine, warm orange, cobalt blue, lemon yellow, cadmium red medium, cadmium yellow, burnt umber

Picture tape

2B pencil

Putty eraser

The tonal sketch for this project.

1 Reproduce the basic lines of the sketch on Waterford rough surface 30gsm (140lb) paper using a 2B pencil. Use picture tape at the corners only to secure it to the board. Wet the sky with clean water and a 37mm (1½in) flat brush, using the edge of the brush to cut in the clean lines around the chimneys and rooftops.

2 Pick up some dilute raw sienna on the 25mm (1in) flat brush and lay it over the lower part of the sky. Working wet into wet, pick up dilute warm orange and add touches from the midpart of the sky upwards, allowing the colours to bleed together. Quickly prepare a dilute mix of Prussian blue and French ultramarine and lay this over the top part of the sky.

3 Change to a size 12 round brush. Mix cobalt blue with lemon yellow and use this recessive green to develop some background foliage on the paper once the sheen has faded (i.e. so the paper is not wet, but not quite dry either). Allow the colour to bleed out a little. Vary the colour with raw sienna.

4 Still using the size 12 brush, use a mix of French ultramarine and lemon yellow to develop the darker area between the buildings. Change to a size 4 round and carefully work around the figures at the far end of the street with a mix of French ultramarine and raw sienna.

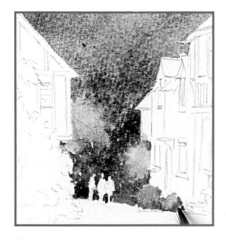

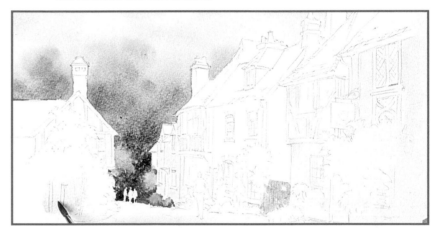

5 Still using the size 4 round, pick up some lemon yellow and drop it in for some lighter areas, letting the colour bleed in. While wet, pick up burnt sienna and develop the ground-level plants in the background.

6 Using a 12mm (½in) flat synthetic brush, lay in a pale wash of raw sienna over the buildings on the right-hand side, leaving gaps of clean paper for areas such as foliage and windows. Change to a size 6 round for smaller areas, and the buildings further down the street. While wet, develop the raw sienna areas, overlaying a few areas and using stronger colours.

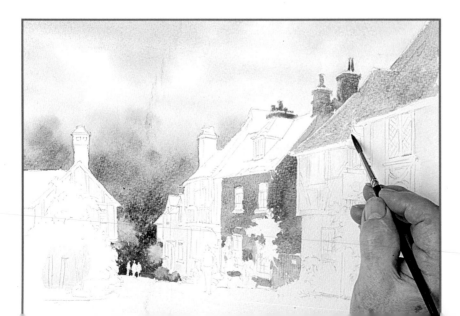

7 Still using the size 6 round, block in the central house with a mix of raw sienna and cadmium red medium. Again, leave the windows and foliage clean. Paint the chimneys with the same brush and mix. Vary the colour by altering the proportions of the colours, and adding a little French ultramarine. Dilute the colour and block in the rooftop of the rightmost building.

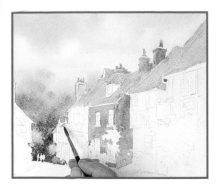

8 Using various combinations of French ultramarine, raw sienna and cadmium red medium, paint the remaining rooftops on the right-hand side of the street.

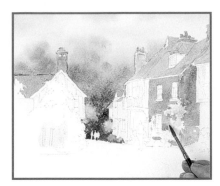

9 Paint the chimney and rooftop of the building on the left-hand side with the same mix. Still using the size 6 round brush, block in the foliage in front of the red house with lemon yellow, then drop in Prussian blue for shading.

10 Add a little raw sienna to mute the colour at the base of the foliage, then begin to paint the rest of the foliage down the street using various combinations of the same three colours.

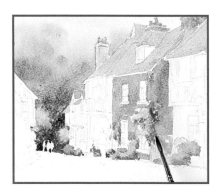

11 Continue to paint the foliage in front of the houses with the three colours. Add combinations of other colours, such as cadmium yellow, for subtle natural variation.

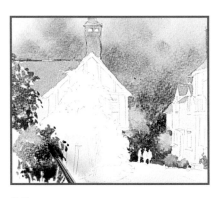

12 Paint the silhouetted trees on the left-hand side of the painting with a mix of French ultramarine and lemon yellow, leaving a few gaps for interest, and vary the hue with a little raw sienna.

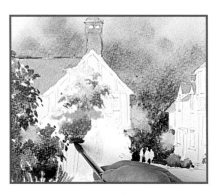

13 Use lemon yellow and the size 6 round brush to block in the tree in front of the right-hand building, adding French ultramarine for the shading.

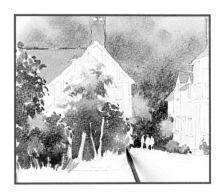

14 Use the same colours and technique to work down to street level, working around the fenceposts and details as shown. Flick some strokes out from the base to suggest longer grasses.

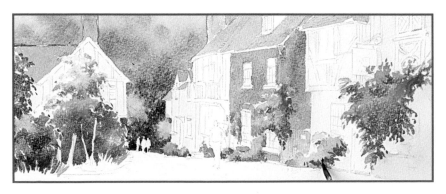

15 Paint the foliage on the right-hand side of the street with lemon yellow, adding touches of raw sienna. Use the tip of the brush to suggest leaf detail. Add French ultramarine to darken and shade, particularly on the right-hand side; then shade the small bush just to the left using the paint left on your brush.

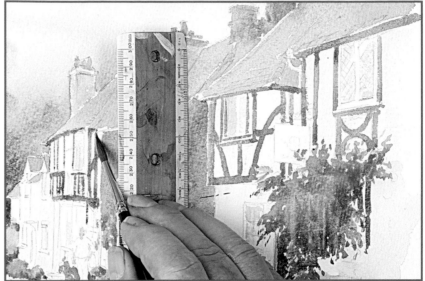

16 Make a dilute mix of raw sienna and cadmium red medium and paint the skin on the figures in the background, and the midground (see inset).

17 Using strokes of the size 6 round brush that roughly follow the shape of the leaded panels in the windows, use the mix of Prussian blue and French ultramarine to paint in reflections of the sky on the right-hand side. Note that the windows are not perfectly flat, so leave some blank to add character. Still using the size 6 round brush, paint in the beams and some of the features such as doors using fairly dilute burnt umber. Vary the strength by adding more or less water, and vary the hue with French ultramarine. Use the ruler to help you, being sure not to lay it flat on the painting surface. Note that the beams will appear narrower as they recede.

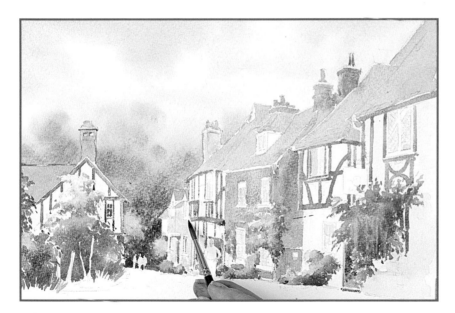

18 Paint in the remaining beams, including those on the side of the building. Glaze the yellow house near the end of the street with another layer of raw sienna and the size 6 round brush.

19 Establish shadows on the roof of the left-hand house using dilute French ultramarine and the size 6 round brush.

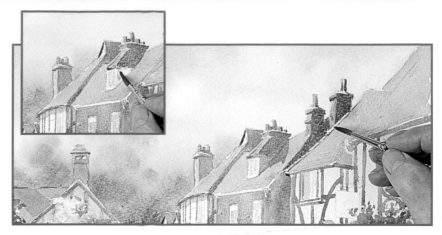

20 Glaze the facing wall of the left-hand house with French ultramarine, then begin to add shadows to the street on the right-hand side. Start at the far end of the street, and add shadows where appropriate; stronger under gables and walls, and more dilute on the sloping rooftops.

21 Continue developing the shadows on the right-hand buildings, paying careful attention to complex shadows, such as those cast by the dormer windows (see inset) and to shapes caused by shadows such as the details of overhanging roof tiles.

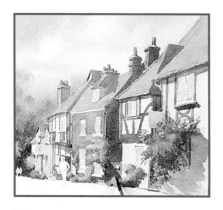

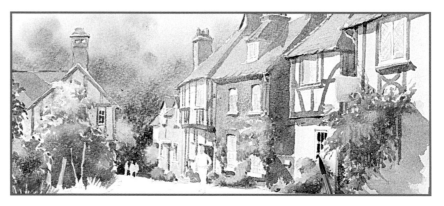

22 Still using French ultramarine and the size 6 round brush, continue developing the shadows. Begin to cut into foliage areas to reshape them.

23 With a stronger mix of French ultramarine, begin to pick out the darker areas of the windows. On the older windows, note that some parts will remain white.

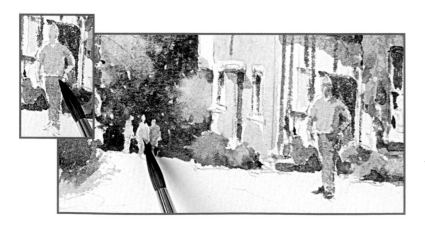

24 Use very dilute cadmium red to paint the midground figure's top, and dilute Prussian blue for the trousers, leaving a slight white line as a highlight on the left-hand side (see inset). Add a little shading with dilute French ultramarine and paint his shoes with dilute burnt umber. Paint the background figures with hints of various dilute colours. Do not overwork these – they need only a touch of colour and some French ultramarine blue to hint at their form.

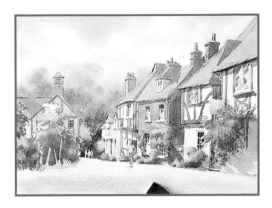

25 Lay in a wash of dilute raw sienna over the street using the 25mm (1in) flat brush, then overlay it with less dilute raw sienna towards the bottom of the painting to lead the eye forward and down the street.

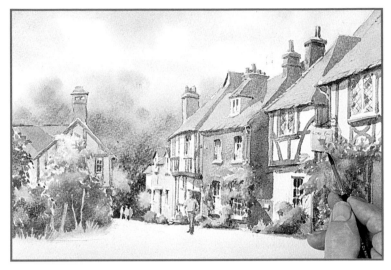

26 While the raw sienna dries, pick up a virtually undiluted dark mix of French ultramarine and burnt umber with a size 4 round brush. Draw in fine lines to develop details in the leaded windows, to strengthen the beams and to add the support for the sign. Subtly suggest the direction of the tiles – but do not be tempted to try and put them all in! You are aiming to simply suggest the tiles. Dilute the mix and add a little copper kettle to the sign.

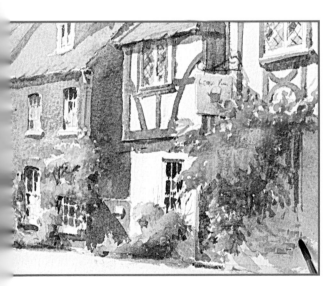

27 Add the suggestion of bricks on the wall of the rightmost building using a mix of raw sienna and cadmium red medium with the size 4 round brush. Use the tip of the brush with the dark mix to detail the mortar a little.

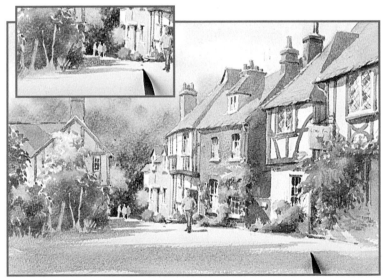

28 Swap to the size 12 round brush and use dilute French ultramarine to add shadows across the foreground, starting from the back (see inset) and working them into the foliage where applicable. Remember to add a cast shadow from the central figure. Once dry, use a putty eraser to remove any pencil lines to finish.

Overleaf:
The finished painting.

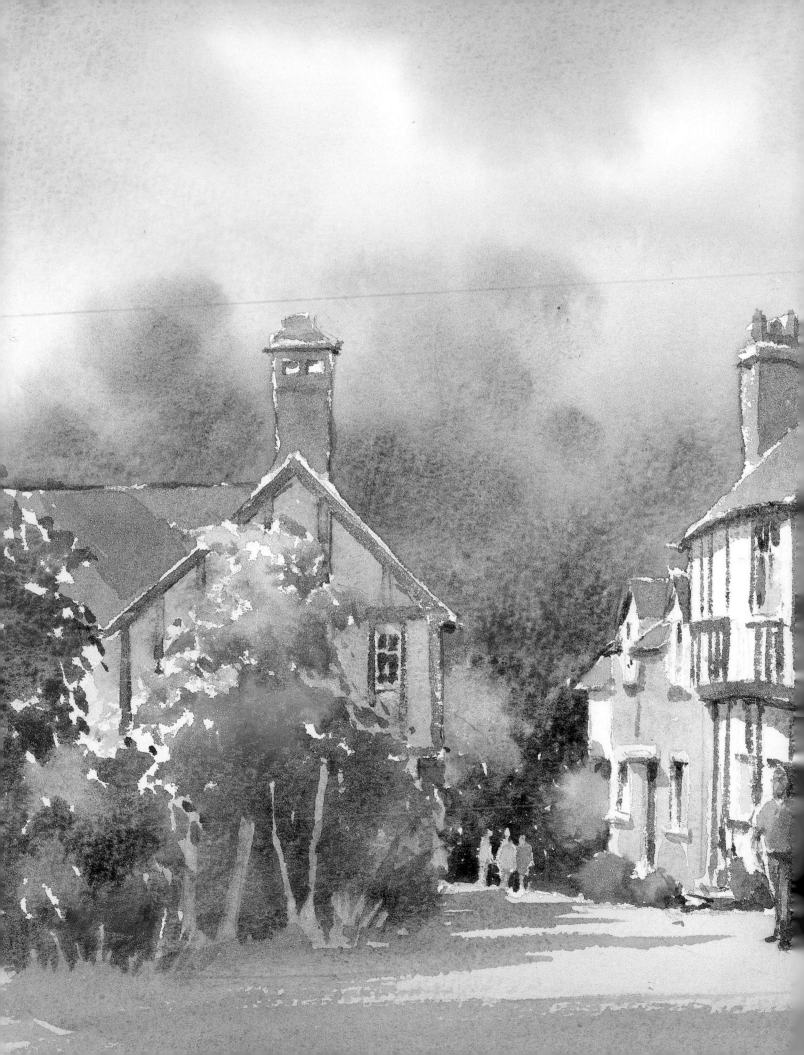

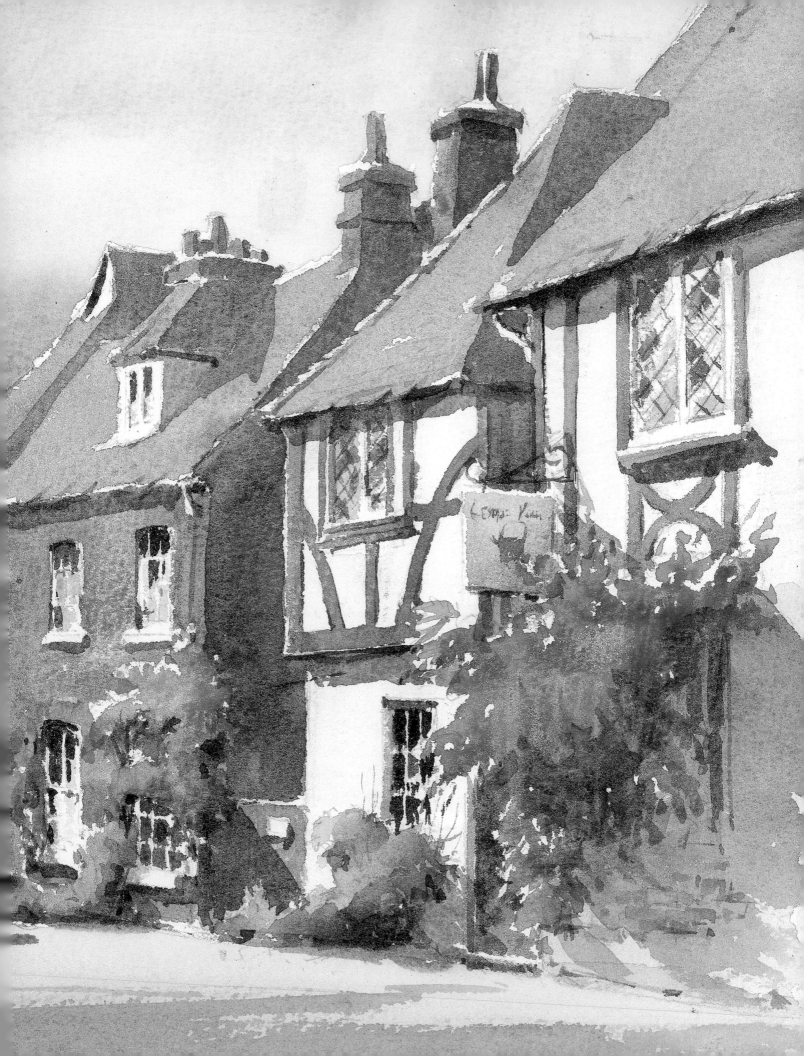

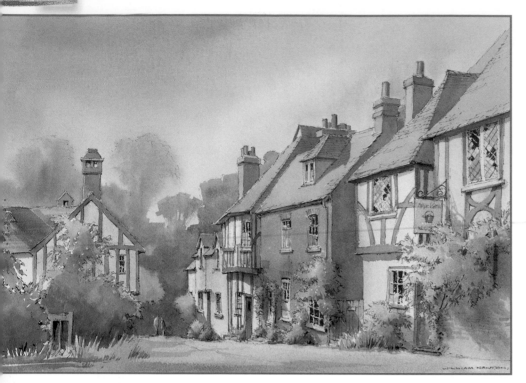

Chilham

This variation of the project is a pen and wash demonstration painting executed during a two hour visit to an art club. It is an example of the ink being used at varying strength depending on the need. Strong penwork is used on the underlines such as gutters and in windows. The penwork is stronger in the foreground and weaker in the background, with only thin light lines on the tops of roofs and in the distance. For the background trees, no ink was used at all so as to retain the feeling of natural recession.

Wendens Ambo

This pen and wash study was painted on location in this very beautiful part of north Essex, UK, which has been a popular location for artists for many years. However, a good subject is always worth another look, a fresh approach, a new painting.

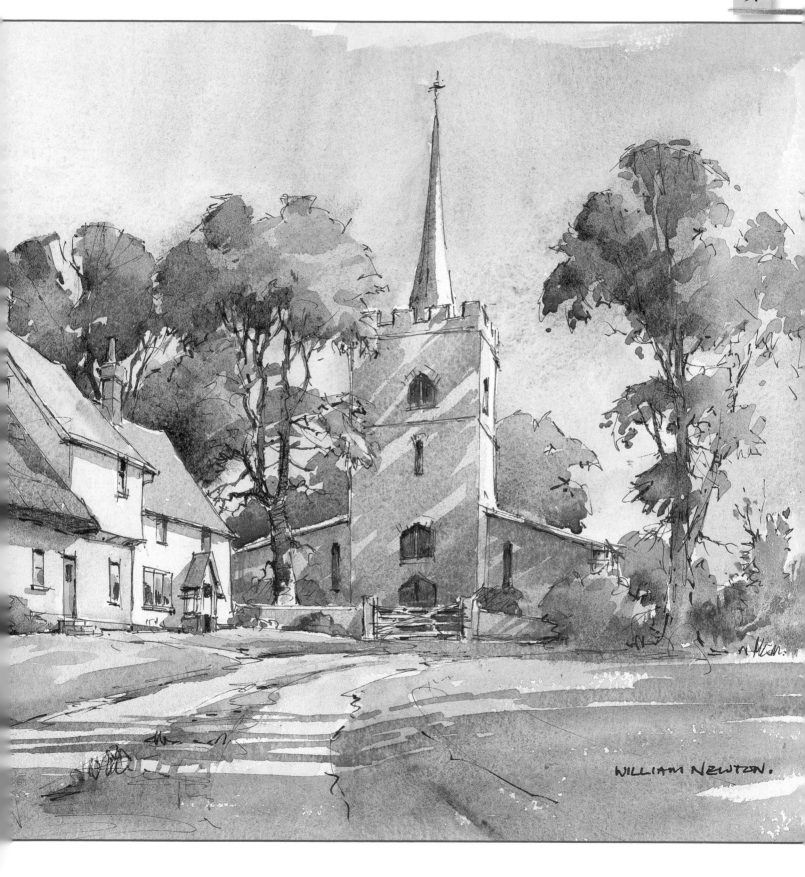

WILLIAM NEWTON.

Magdalen College

Magdalen College of Oxford University covers many acres – it is a vast place. This project shows a particularly attractive viewpoint of just part of it. Following this demonstration will result in a scene bathed with warm light. In order to capture what is, after all, a very complex subject, the lines of the sketch are simplified as far as possible without compromising the strong impression of beauty and a sense of place.

You will need

Waterford rough surface 300gsm (140lb) paper

Brushes: 37mm (1½in) flat synthetic, 25mm (1in) flat synthetic, size 12 round, size 6 round, 12mm (½in) flat synthetic

Colours: raw sienna, French ultramarine, Prussian blue, cobalt blue, lemon yellow, cadmium red medium, warm orange

Picture tape

2B pencil and putty eraser

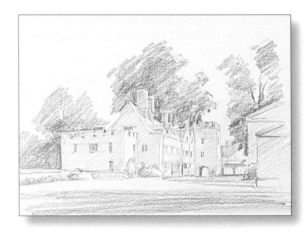

The tonal sketch for this project.

1 With a 2B pencil, draw the basic lines of the sketch on the paper and use picture tape on the corners only to secure it to your board. Wet the building and foreground area with clean water and a 37mm (1½in) flat brush, then pick up dilute raw sienna on the 25mm (1in) flat brush and lay a soft wash over the buildings and foreground.

2 Allow the painting to dry thoroughly before continuing. Wet the sky area with the 37mm (1½in) flat brush. Use the edge of the brush to cut around the architectural detail, ensuring you leave this dry. Lay in a soft wash of a mix of French ultramarine and Prussian blue with the 25mm (1in) flat brush.

3 Pick up the board and tip it to let the pigment mingle over the picture. Allow the gloss of the wash to fade a little, then place it flat down.

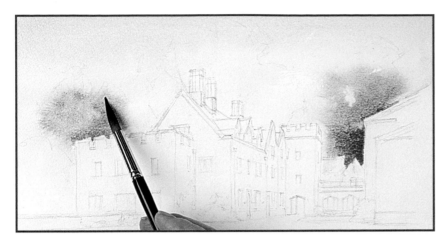

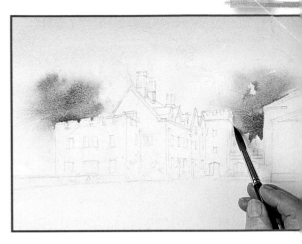

4 Make a recessive green mix of raw sienna with a little cobalt blue and use the size 12 round and drop it in wet into wet on the right-hand side. Add some more cobalt blue for the darker areas. Do the same on the left-hand side, using the tip of the brush to work into the crenellations. Because the buildings are dry, the colour should not flow into them.

5 Add some darker areas near to the light areas of the trees – here some more blue has been added near a small hole on the right-hand side, and next to the building to create contrast.

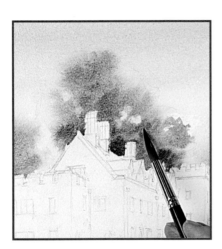

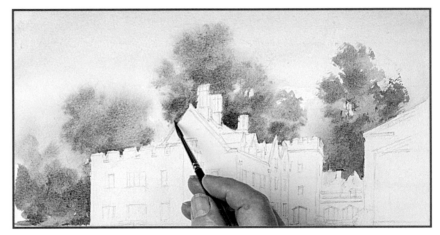

6 Still using the size 12 round, pick up lemon yellow with a little raw sienna and drop in a tree in the centre, working carefully around the architectural details. Add some French ultramarine to shade it and create texture.

7 Paint another tree on the far left-hand side with the same colours (lemon yellow, raw sienna and French ultramarine), then change to the size 6 round. Use the tip and side of the brush to begin to pick out and sharpen details over the right-hand tree using raw sienna and French ultramarine. Still working wet-in-wet, use the size 6 with raw sienna and French ultramarine to add subtle details to the remaining trees before allowing the painting to dry.

> *Tip*
>
> As the paper begins to dry, the spreading effect will be lessened; this means trees placed later (see step 6) appear to advance, an effect which is enhanced through the use of warmer greens and blues.

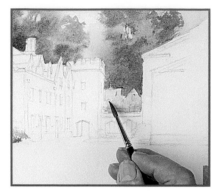

8 Still using the size 6 round, paint the flowers in front of the college using very dilute cadmium red medium. Dab it lightly with kitchen paper to lift out and soften it (see inset). While wet, add lemon yellow to the dilute cadmium red medium and create shadows around the base of the area.

9 Knock back the background buildings using dilute cobalt blue and the size 6 round. Strengthen the colour towards the bottom in the shadow.

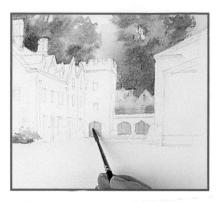

10 Add a hint of lemon yellow in the deepest shadows, and use the same colour through the arches below. Add a hint more cobalt blue and paint the doorway to the left.

11 Use the tip of the size 6 round to paint the windows on the right-hand side of the college with dilute cobalt blue.

12 Make a warm grey from lemon yellow, cadmium red medium and cobalt blue, and paint in the rooftop of the main building. Vary the mix over the rooftop to represent light and shadow, and also to create variety.

13 Paint the windows on the left-hand side of the college with French ultramarine, using the tip of the brush to ensure you retain the detail.

14 Mix French ultramarine, raw sienna and lemon yellow for a green mix, and use it to tease in foliage around the flowers. Vary the mix for natural variation.

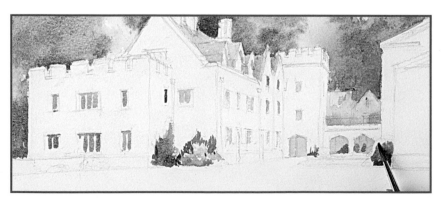

15 Still using the size 6 round, paint in a few shrubs and small trees on the right-hand and left-hand sides, again varying the colours in the same way.

16 Add the flowerbed on the left-hand side using a stroke of French ultramarine and a stroke of lemon yellow. Use the tip of the size 6 round to tease the lemon yellow up a little for texture.

17 Change to a size 12 round and lay in a wash of a French ultramarine and warm orange mix over the right-hand building. Use the tip of the brush to add some hints of pure warm orange and pure French ultramarine for detail.

18 Change to the size 6 round and use the same mix to paint the shaded arches and the top of the tower. Work down over the window and let the colour soften away as you work down.

 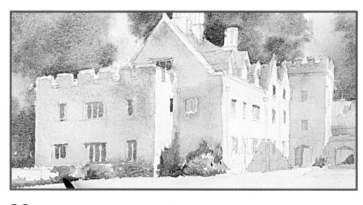

19 Still using the size 6 round and the same mix, paint the shadow of the right-hand building on to the main building. Continue to paint the side of the main building, varying the proportions of the mix to simulate the staining and age of the wall.

20 As you reach the bottom of the page, paint straight over the green vegetation, but not over the pinks of the flowers, then paint the leftmost building.

 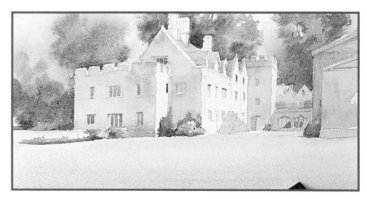

21 Change to a 12mm (½in) flat and overlay the rear part of the right-hand building with a glaze of the same mix. Once dry, use the ruler to help you draw fine French ultramarine detail on the right-hand building using the size 6 round.

22 Use the 25mm (1in) flat brush to lay in a wash of lemon yellow over the lawn, using the edge of the brush to ensure you do not go over the building. Working wet into wet, lay in some dilute French ultramarine over the foreground. Allow the paint to dry before continuing.

23 Change to the size 6 round brush. Use a dilute mix of French ultramarine and warm orange to paint the shadows on the chimneys (see inset), then glaze the rooftops of the main building using dilute French ultramarine.

24 Use the size 4 round with a dark mix of French ultramarine and burnt sienna to begin to add some shadow details over the building. Use the ruler to put in straight lines like gutter piping.

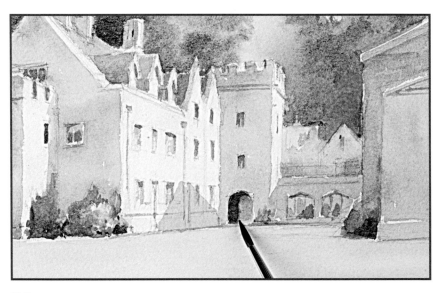

25 Reinforce the red of the flowers with a dilute glaze of cadmium red, applying the paint with the size 4 round.

26 Overglaze the arches on the right-hand side with dilute washes of a grey cadmium red, cobalt blue and lemon yellow mix.

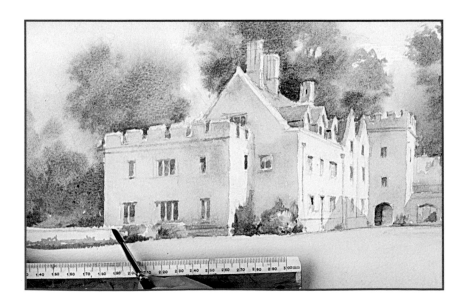

27 Use the same grey mix to pick out more details on the right-hand building, to tidy the windows and doors on the main building, and to add the masonry on the left-hand side. Use a ruler to help you achieve straight lines on the masonry.

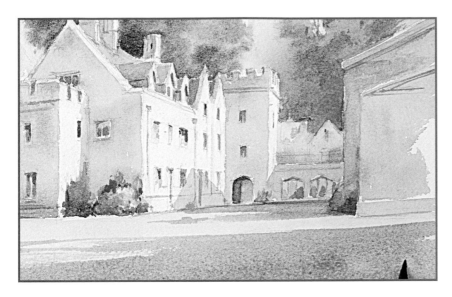

28 Change to the size 12 round and load it with a dilute shadow mix of French ultramarine, a little cadmium red medium and a little lemon yellow. Lay in shadows of the right-hand building on the ground, connecting it with the section that extends up the main building's wall. Next, extend the shadows across the foreground lawn.

29 Strengthen the shadow in the very foreground and use the same mix to paint some shadows over the right-hand building and under the flowerbed.

30 Use the tip of the size 4 with the shadow mix to paint in two small figures under the arch to finish.

Overleaf:
The finished painting.

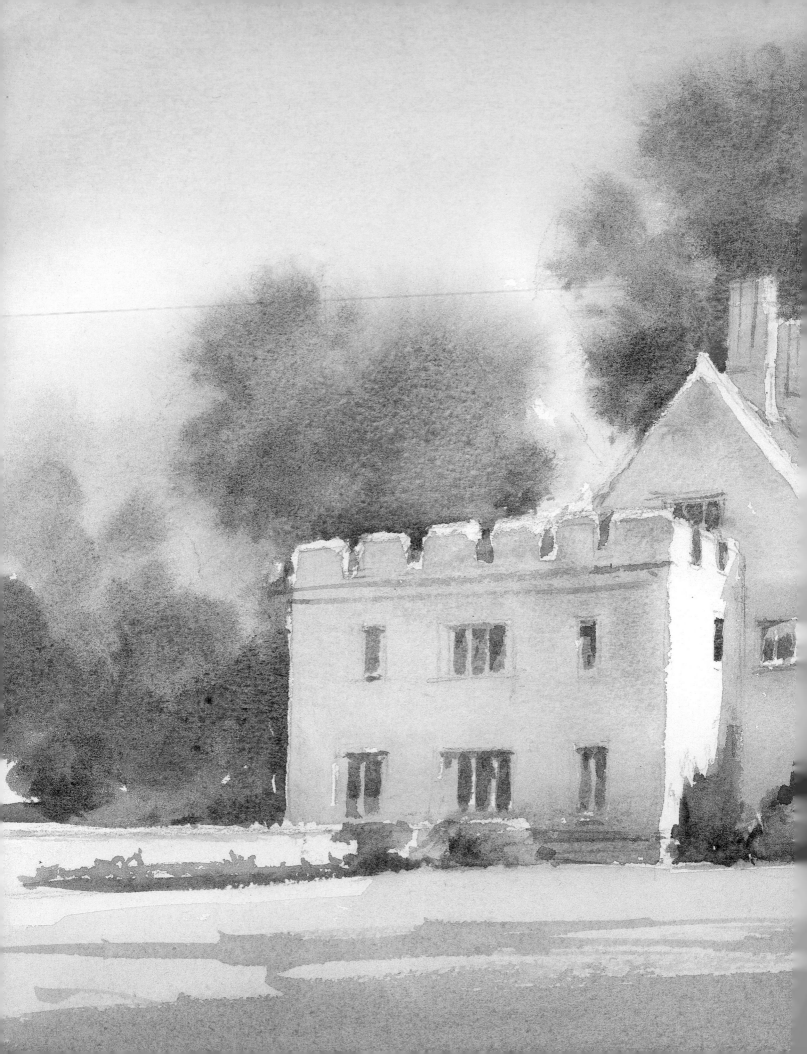

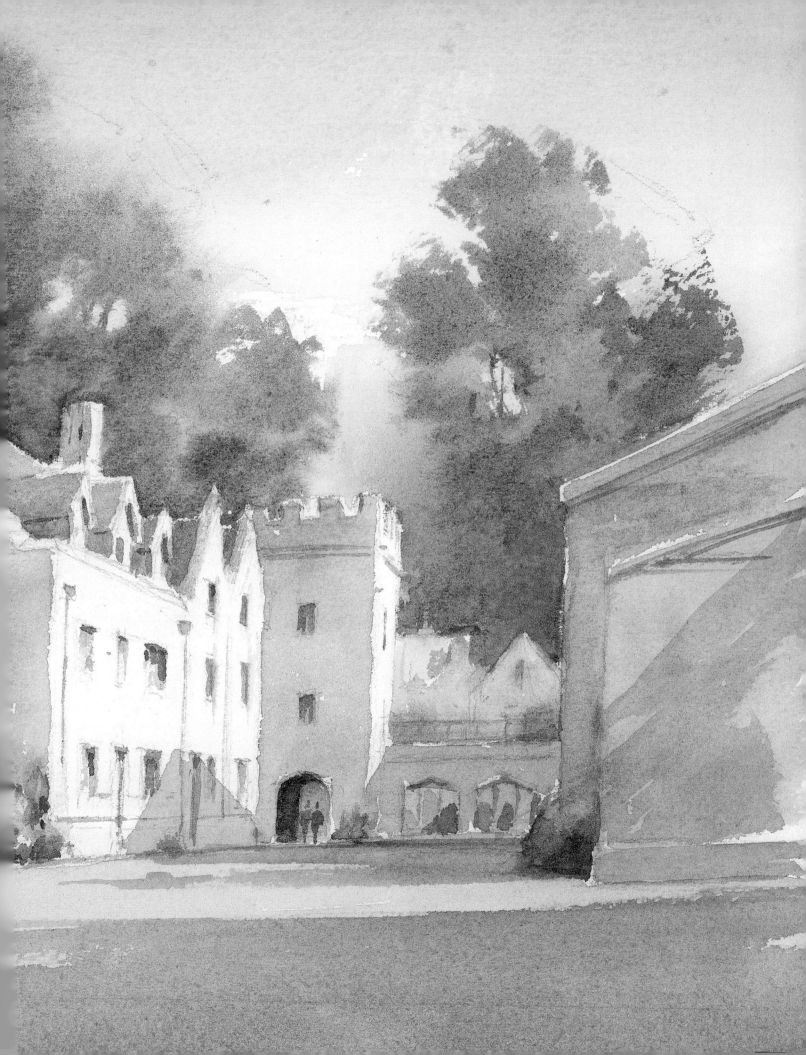

Carfax, Oxford

This painting was a studio work developed from a smaller pen and wash sketch done some years earlier. The trick is to simplify complicated subjects like this as far as possible, while still maintaining the busy nature of the scene.

Angles sur l'Anglin

This is an outdoor demonstration painted from a small island on the River Anglin in France. The village has a ruined chateau high up on the left and a watermill complete with wheel on the other side of this lovely bridge.

Cannon

This still life study shows the techniques used to paint round objects like the barrel and the wheels of the cannon while still bathing the scene in strong light by creating shadows.

You will need

Waterford rough surface 300gsm (140lb) paper

Brushes: size 12 round, size 6 round, size 4 round, 25mm (1in) flat synthetic, 12mm (½in) flat synthetic

Colours: raw sienna, French ultramarine, burnt sienna, cadmium red medium

Picture tape

2B pencil

Ruler

Putty eraser

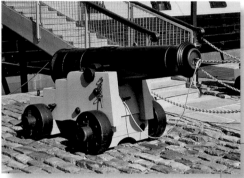

The source photograph for this project.

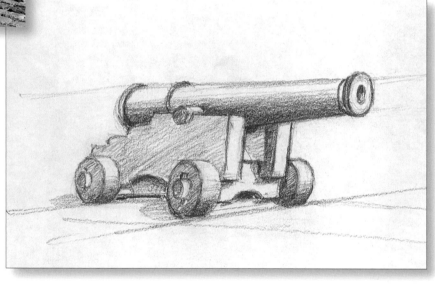

The tonal sketch for this project.

1 Use a 2B pencil to reproduce the basic lines of the sketch on to the paper, and secure it to the board using picture tape on the corners. Use the size 12 round to apply raw sienna across the front of the carriage.

2 Extend the colour over the rest of the carriage and then wipe away excess paint from the brush. Use the dry brush to lift the paint on the front to lighten the colour. Allow the colour to dry.

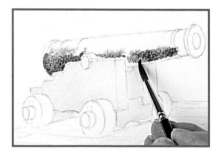

3 Change to a size 6 round brush and carefully wet the cannon itself with clean water. Create a dark mix of French ultramarine and burnt sienna and paint the lower half of the cannon.

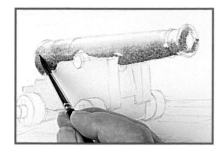

4 Rinse the brush and draw the colour up over the top half of the gun, allowing it to blend away to nothing.

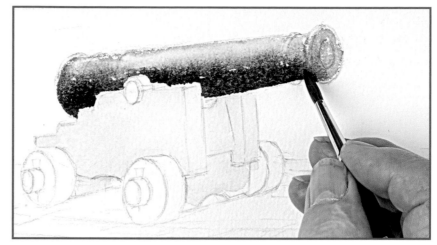

5 Use a strong mix of French ultramarine and burnt sienna to strengthen the very bottom, working wet into wet.

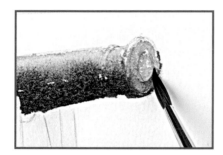

6 Use a touch of the dark mix to suggest the shape of the cannon's muzzle.

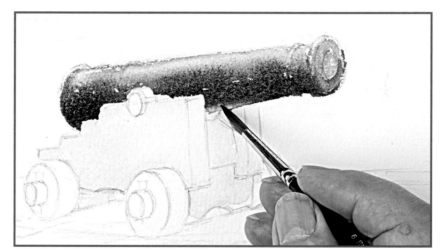

7 Rinse the brush and use the tip to lift out a reflected highlight underneath the cannon's body.

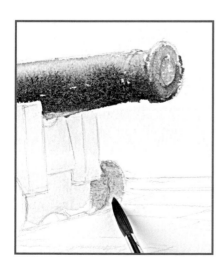

8 Lay in a dilute wash of the dark mix on the wheel on the right of the front of the carriage.

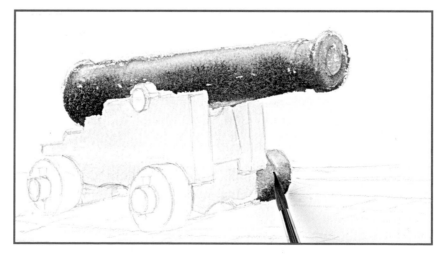

9 Create a gradient on the wheel by strengthening the lower part with a stronger mix of French ultramarine and burnt sienna. Blend the colour upwards on the curve of the wheel.

10 Lay in a dilute wash of the dark mix on the frontmost wheel, rinse the brush and lift out a subtle highlight on the top part of the curve.

11 Lift out a highlight on the curved part of the axle.

12 Still working wet into wet, strengthen the lower parts of the curved areas with a stronger mix of French ultramarine and burnt sienna and blend it upwards, following the line of the curve.

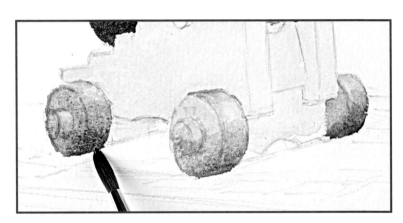

13 Blend a little colour into the top of the curve as shown. Be careful to ensure that the colour does not creep into the face of the wheel. If it does, lift it out with the brush.

14 Paint the final visible wheel in the same way.

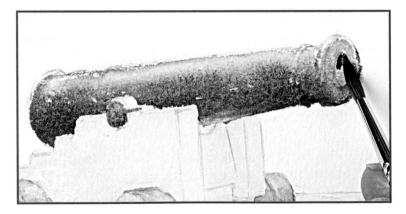

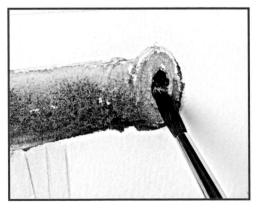

15 Paint the cannon's trundle (the part of the cannon resting on the carriage) using the same techniques as for the wheels for the curved parts, and the techniques for the barrel of the cannon for the small supports. Use the darkest mix to paint into the top of the bore.

16 Extend the colour down inside the bore, letting the colour fade slightly towards the bottom.

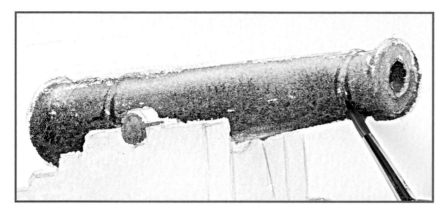

17 Using the strong dark mix, use the tip of the size 4 round to paint in the shadows cast by the reinforcing rings. Follow the curve of the barrel carefully. Allow the painting to dry completely before continuing.

18 Make a dilute mix of raw sienna with touches of cadmium red medium and French ultramarine. Use the size 6 round brush to glaze the side of the carriage facing you.

19 Use the same mix to paint the shadow the barrel is casting over the carriage, and the other small shadows on the front of the carriage.

20 Glaze the faces of the frontmost wheel and axle using the size 6 round and dilute French ultramarine.

21 Working wet into wet, drop in a little of the dark mix (French ultramarine and burnt sienna) at the bottom of the wheel.

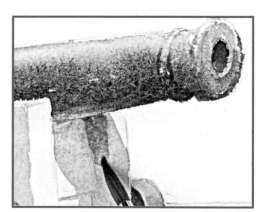

22 Paint the flat faces of the other wheels, and the cannon trundle, in the same way. Once dry, reglaze the very bottom of the curves of the wheels to match the darks on the faces.

23 Change to the size 6 round. Using the dilute mix of raw sienna with touches of cadmium red medium and French ultramarine, paint the shaded section under the cannon as shown.

24 While the paint is wet, add a little more of the same mix at the top, and blend it downwards until it fades away.

25 Reglaze the very bottom of the curves of the axles to match the darks on the faces now that the wheels have dried.

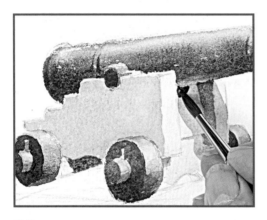

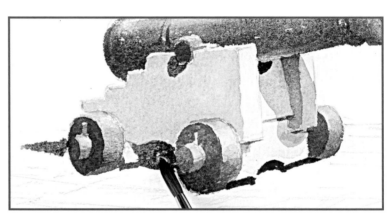

26 Using the dilute mix of raw sienna with touches of cadmium red medium and French ultramarine, paint the shaded sections under the carriage by the rear axle, and under the cannon itself.

27 Make a dark mix of French ultramarine with a little burnt sienna and paint the shadow behind the trundle and underneath the carriage.

28 Paint the shadows the wheels cast on the ground using a slightly more dilute mix of the same colour. Suggest the texture of cobbles with the placement of the paint.

29 Using the same dilute mix of French ultramarine and burnt sienna, paint the bolts on the carriage and the shadows they cast.

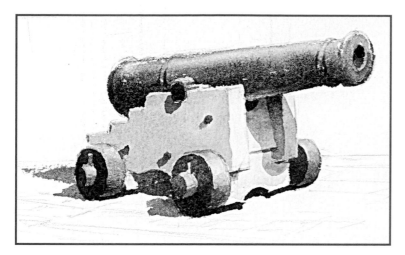

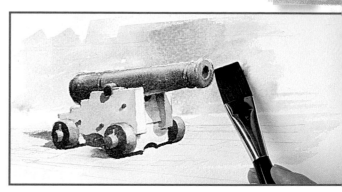

30 Allow the painting to dry, then make any tonal adjustments you feel necessary using the same mixes – the dark mix (French ultramarine and burnt sienna) for metal, and the raw sienna with touches of cadmium red and French ultramarine for wood.

31 Using the 25mm (1in) flat brush, draw some very dilute raw sienna over the ground below the horizon line (actually just the edge of the dock), working up to but not over the cannon. Pick up a dilute mix of French ultramarine with a little burnt sienna and paint in a light broken wash over the background above the horizon, again working up to but not over the cannon itself.

32 Using the dark mix (French ultramarine and burnt sienna), hint at the surface of the cobblestones by painting a few details with the point of the size 6. Draw a line to suggest the edge of the dock with the same brush and mix.

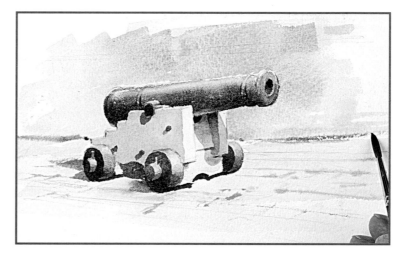

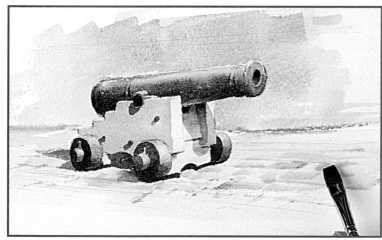

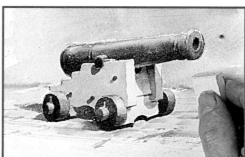

34 Make any final adjustments you feel necessary, then allow to dry completely. Use a putty eraser to remove any pencil lines.

33 With the 12mm (½in) flat brush and a mix of French ultramarine and raw sienna, suggest the shape of the cobblestones near the cannon.

Overleaf:
The finished painting.

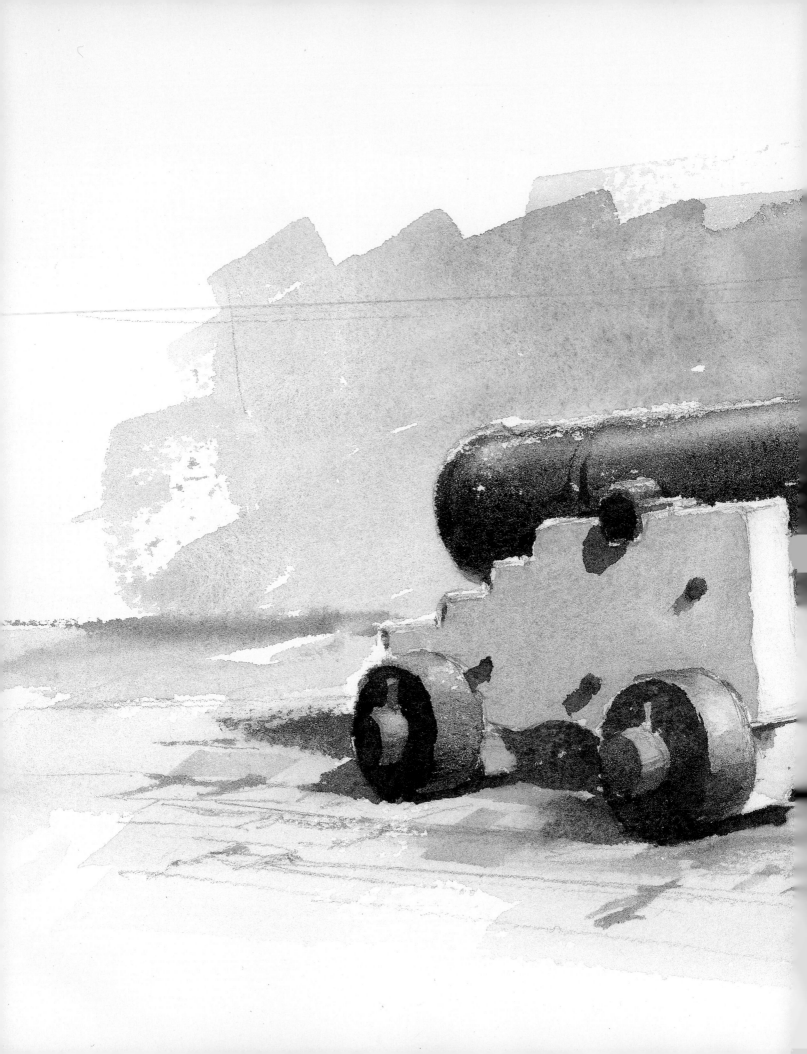

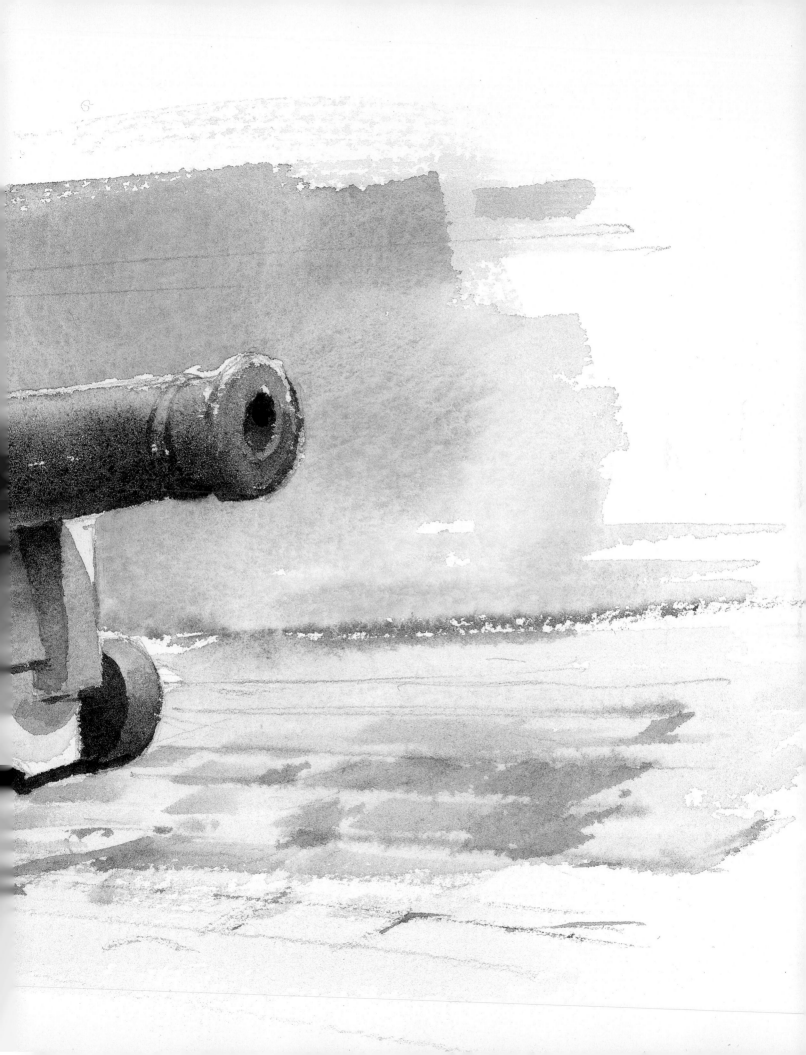

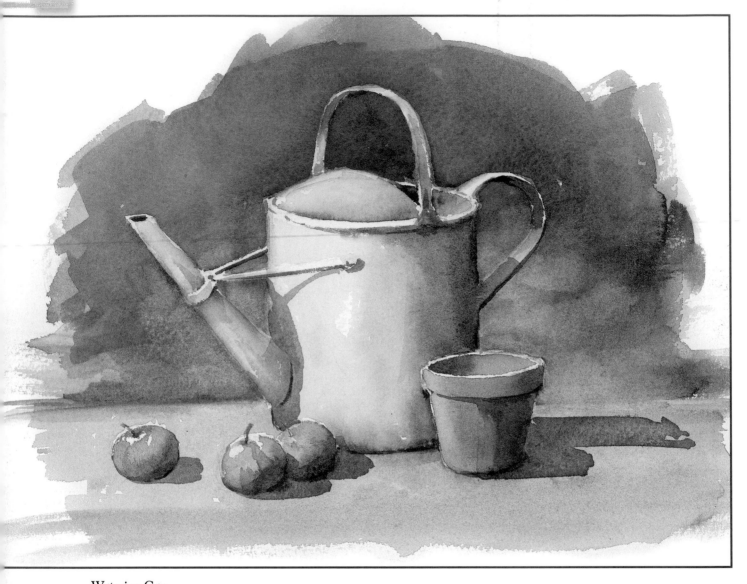

Watering Can

*The most mundane items found around the house and garden can make good
subject matter for still life painting.*

The Old Stone Well

*This old well is in the gardens of a beautifully restored farmhouse in Brittany,
France. It is a great still life subject with good opportunities for depicting light and
the forms of the weathered stone shapes.*

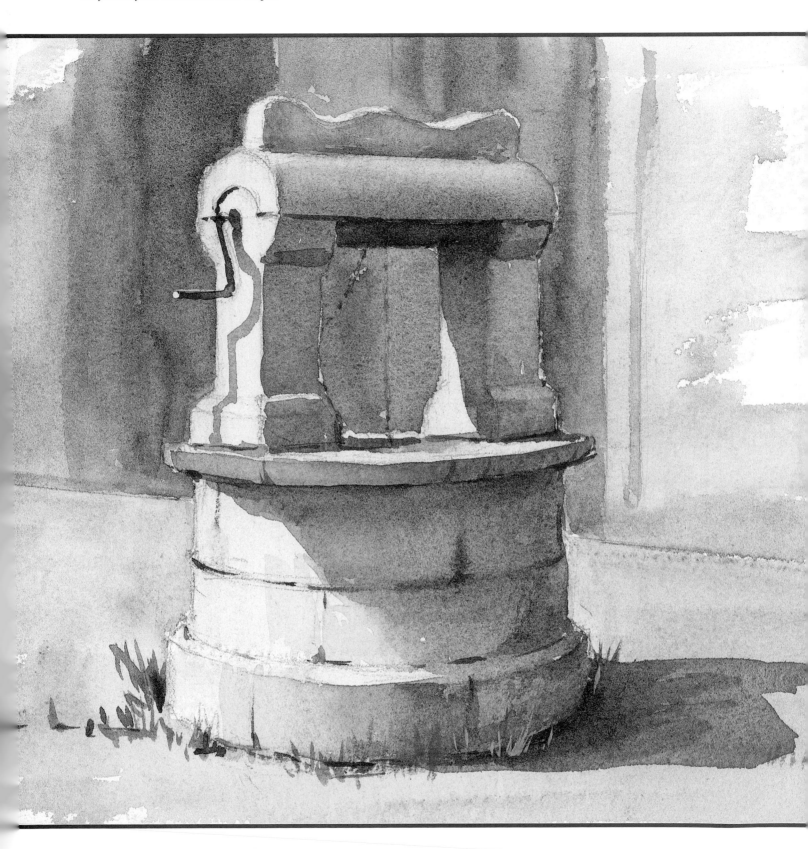

John

As we have said, portrait painting can be difficult but whenever any of my students have said that something is very difficult, I always reply that that is the very thing that they should practise. Indeed, it is no bad thing to get out of one's comfort zone and try. It is possible to make a good painting with a poor likeness and, conversely, a bad painting with a good likeness. The trick is to try to bring the good parts of each together. It ought to be noted that this is a demonstration painting – a masterpiece might take a little longer!

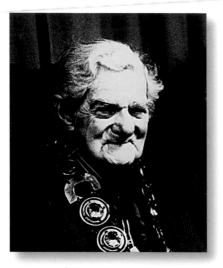

The source photograph for this project.

You will need

Waterford rough surface 300gsm (140lb) paper

Brushes: 25mm (1in) flat synthetic, size 12 round, size 6 round, 12mm (½in) flat synthetic

Colours: burnt sienna, French ultramarine, raw sienna, cadmium red medium, burnt umber

Picture tape

White acrylic artists' ink

2B pencil

Putty eraser

Tip

Because a good likeness is critical, work directly from the photograph. You may wish to produce a tonal sketch to familiarise yourself with the subject's features. The better you know your subject, the better the final result.

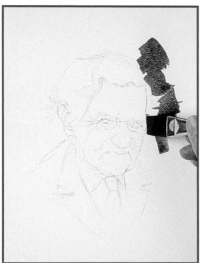

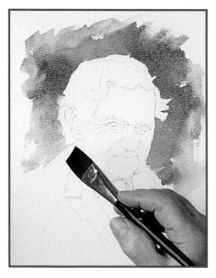

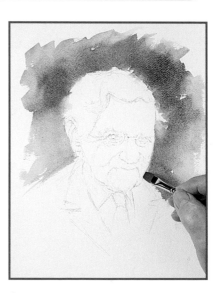

1 With a 2B pencil, draw the basic lines of the portrait on the paper and use picture tape on the corners to secure it to your board. Mix burnt sienna with French ultramarine and begin to block in a loose background around the subject with the 25mm (1in) flat brush, working right up to his face.

2 Dilute the paint slightly. Using the 25mm (1in) flat brush, apply it on the left-hand side and soften the colour at the edges of the background using clean water.

3 Swap to a 12mm (¼in) flat and soften the background around the subject a little using clean water.

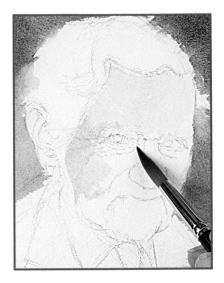

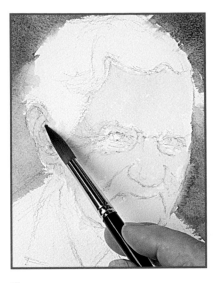

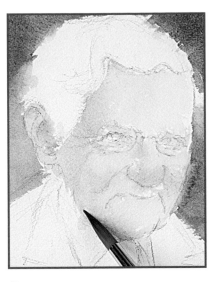

4 Make a flesh wash from raw sienna and cadmium red medium. Use the size 12 round to apply a dilute mix over his forehead, and strengthen it slightly over his cheek.

5 Continue over the rest of the face with the same dilute flesh mix, leaving a few areas of clean paper for texture and highlights. Use the slightly less dilute mix for the ear.

6 While the paint is still wet, work in warmer, stronger areas on the nose, cheek, and under the brow and chin.

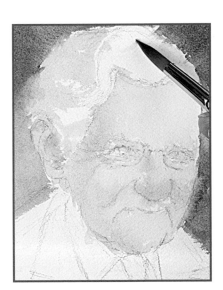

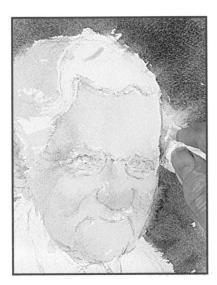

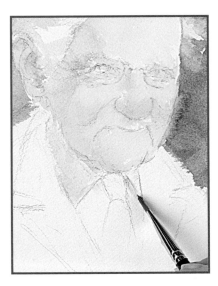

7 Still using the size 12, paint the shadowed and darker areas of the hair with a dilute grey mix of burnt sienna and French ultramarine.

8 Lift out a little hair on the right-hand side by wetting the area with a 12mm (½in) flat brush, then dabbing it with kitchen paper.

9 Add some subtle shading to the shirt with dilute French ultramarine. Turn the brush for finer lines as shown.

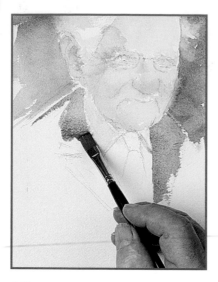

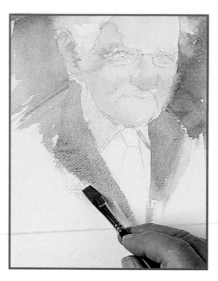

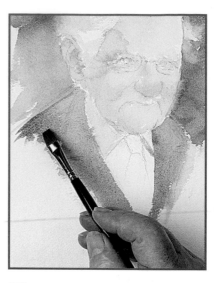

10 Still using the 12mm (½in) flat brush, mix burnt umber with a little French ultramarine, and paint the lapels of the suit.

11 Add a few hints of the same colour around the shoulders and below the lapels, then fade it away with light strokes as the paint on the brush is used up.

12 Working wet into wet, add a little more French ultramarine to the mix to darken it, and suggest darker shadows on the jacket. Allow the painting to dry.

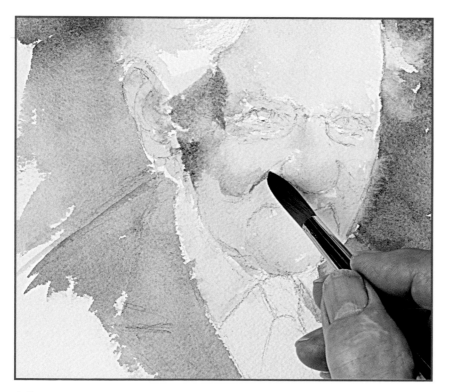

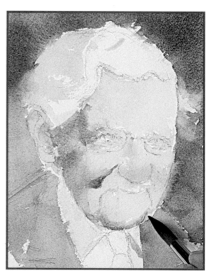

14 Continue working down this side of the face and under the chin using the same brush and paint mix. Soften the colour round the curve of the chin with clean water.

13 Add a little French ultramarine to your flesh mix (raw sienna and cadmium red medium) and use the size 12 round brush to begin to suggest the darker shadows on the side of the subject's face. Soften the colour in with clean water for rounded areas, such as the cheek, and use the tip of the brush for harder recesses.

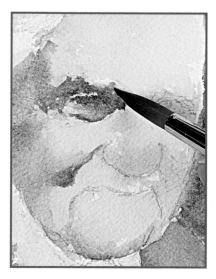

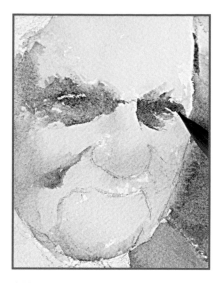

15 Use the same mix and brush to paint the shapes around the eye socket on the left-hand side of the picture, following the shape on your reference closely.

16 Continue working around and under the eye. The eye itself is hidden in shadow, so use slightly more French ultramarine to hint at the shape of the eye rather than trying to depict it exactly.

17 Paint the other eye in the same way. Note that the brushstrokes around the eyes will help to define and sculpt the bridge of the nose. Use the tip of the brush to add the fine lines around the eye.

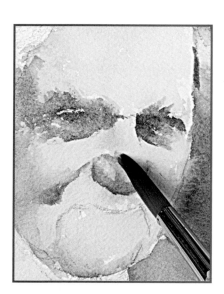

18 Add more cadmium red medium to the original mix and use this slightly redder mix to paint in a few strokes to define the nose. While the paint is wet, soften the colour in with clean water, using the movement of the brush to draw and shape the paint.

19 Use the flesh mix from step 18 with more blue to add in the darkest parts around the nose. Use this sparingly, and do not allow it to bleed too much into the nose itself.

20 Paint the mouth with the same mix, then soften the colour in with clean water. Use the very dilute mix to develop the chin a little.

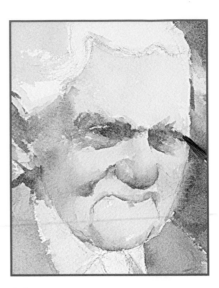

21 Change to a size 6 round. Use a slightly stronger mix of raw sienna, cadmium red medium and a little French ultramarine to paint the inside of the top of the ear. Soften the colour in to suggest the detail of the ear.

22 Paint the details in the ear in the same way, being careful to record the complex structure fairly faithfully.

23 Use dilute French ultramarine to develop some darker details in the ear, by the back of the jaw, and in the recesses of the eyes.

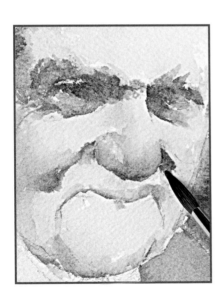

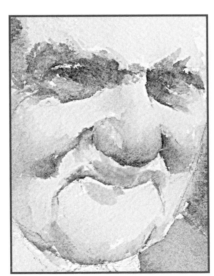

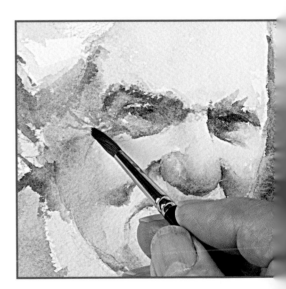

24 Paint in the cheek on the right-hand side using the flesh mix, applying the paint right next to the nose, and softening it away.

25 Add a little more cadmium red to the mix and add some soft shading below the nose and to the middle of the lower lip. Allow the painting to dry completely before continuing.

26 Still using the size 6 round, add more French ultramarine to add some more depth to the eye on the right-hand side, and to add some more wrinkles on the left-hand side. Use the tip of the brush with a slightly less dilute mix to suggest the texture of the eyebrows.

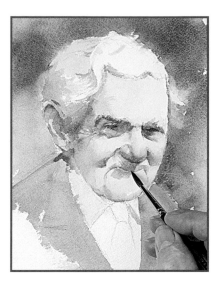

27 Soften the left-hand side with a subtle glaze of French ultramarine, then develop the browline with subtle, almost dry strokes of the flesh mix below the hair. The dry brush technique will let the paper suggest the broken shadows cast by the hair.

28 Continue to develop the hair with the same mix and brush for shadows, suggesting the shape with the brushstrokes, then add a subtle glaze of the original flesh mix to shape the temple.

29 Darken the area of background where the shoulder meets the face with dilute French ultramarine to increase the contrast, then add a soft shadow under the nose with the same colour and soften it in.

30 Use very dilute cadmium red medium to paint the tie, fading it away to nothing at the bottom of the picture. Strengthen the colour with another layer of cadmium red medium dropped in wet into wet, then add a little French ultramarine to shade.

31 Use the same colour for the shadows of the lapels on the suit. Still using the size 6 round, glaze the collar and lapel with dilute French ultramarine to represent the shadow of the subject's head. Overlay the glaze for darker areas.

32 Refer to your source photograph or sketch closely to add subtle glazes for shadows on the cheeks, tie and over the rest of the face.

33 Using the size 6 round brush, use white acrylic artists' ink to suggest wispy, flyaway hair on the right-hand side, and to hint at the texture of his eyebrows.

34 Make any final adjustments using the colours on your palette, then allow the painting to dry completely.

Opposite:

The finished painting.

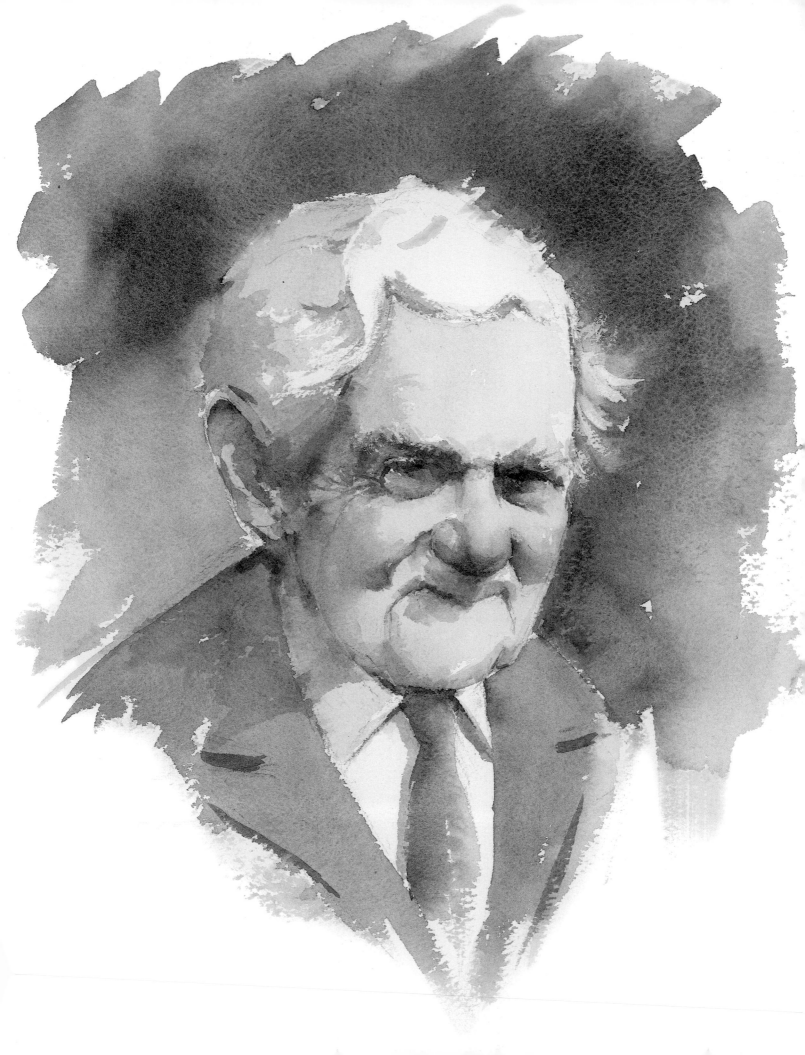

The Three-Year-Old

For this study I thought a certain amount of lifting out and softening of edges might be necessary and desirable in depicting the little girl. Bockingford paper lends itself to this purpose very well.

Having lightly sketched in all the various shapes and lines and being careful with placement of the features, I started painting by putting in the dark background with a strong mix of French ultramarine and burnt sienna with rapid broad brushstrokes. When dry, I was able, using the wet tip of a pointed size 6 round brush, to lift out wispy strands of light coloured hair against the dark background.

Portrait painting requires softness, particularly when painting children where soft graduating washes can give form to the face. For the flesh colours I used cadmium red plus raw sienna fluidly with a little cobalt blue added for darkened areas.

The Seven-Year-Old

*For this second study I have used essentially the same techniques as in the
picture opposite except that – this little girl having darker hair – I have used paler
background washes which has reversed the contrast to dark against light.*

Index

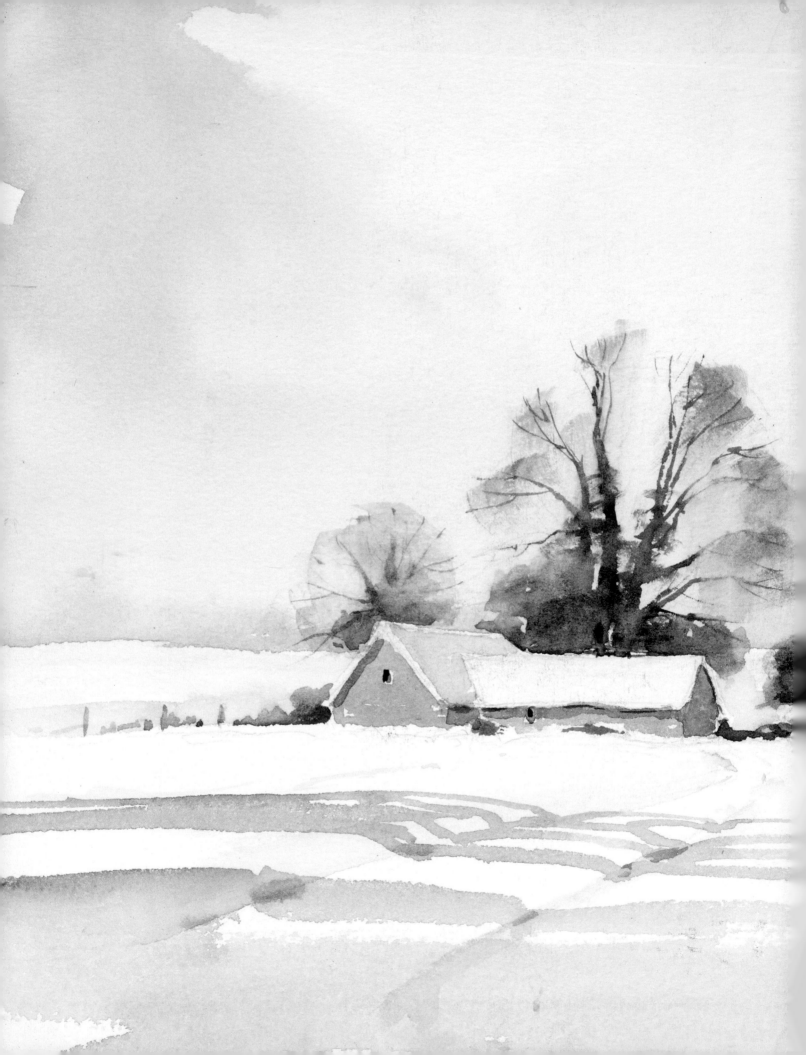